LOST
ROCHESTER
MINNESOTA

LOST
ROCHESTER
MINNESOTA

AMY JO HAHN

THE
History
PRESS

Published by The History Press
Charleston, SC
www.historypress.net

All images are from the History Center of Olmsted County unless otherwise noted.

First published 2017

Manufactured in the United States

ISBN 9781625858320

Library of Congress Control Number: 2017948517

CONTENTS

ACKNOWLEDGEMENTS

I am extremely appreciative of the staff and volunteers at the History Center of Olmsted County, especially Krista Lewis, Ryan Harren and Linda Willihnganz, for their support and help. I was blessed with unlimited access to the History Center's archives and library, and I had a large team of people to turn to when I had questions, needed clarification on facts or required help with finding an elusive photo or data file. The History Center is an amazing resource for genealogists, historians and the general public. Working with everyone at the History Center has been a wonderful experience. All the historic photos are courtesy of the History Center of Olmsted County. I am very grateful for their help with this project.

My family and friends also provided encouragement during this process, and I couldn't have written this book without the unwavering support of my husband, Chris Sattler. This book is a reality because of him. Thank you, Chris. For everything. I love you.

INTRODUCTION

Since its founding in 1854, Rochester has been a city constantly adapting to growth and change, but over the next decade, it will see its most dramatic evolution due to an initiative known as Destination Medical Center (DMC). Led by Mayo Clinic, the DMC initiative promises to drastically change the landscape of Rochester forever by positioning the city "as the world's premier destination for health and wellness; attracting people, investment opportunities and jobs...supporting the economic growth of Minnesota." This economic development plan is momentous in scope, and its presence has raised questions and concerns about how to protect and preserve what remains of Rochester's historic foundation.

Opposing ideas over what defines progress and how old structures can contribute arise in communities facing the prospect of welcomed and needed economic growth and development. Historic preservationists, city officials, politicians, business owners and others debate what to do with historic buildings. While it's true historic structures cannot always be saved due to severe deterioration, unsafe conditions and lack of financing, many can be renovated, restored or adapted for modern use, contributing to the revitalization and economic vitality of a city's downtown, its main artery: Main Street. Since the arrival of the DMC vision in 2013, Rochester has tackled these questions with passionate debate.

This is the perfect time to reflect on Rochester's history. I couldn't fit everything into this book, but I hope it offers an intriguing glimpse into early Rochester. This book is my small contribution to preserving Rochester's past for future generations. Enjoy.

EARLY TRANSPORTATION

In 1854, a flood of immigrants crossed into Minnesota Territory as a result of 1851's Treaty of Traverse des Sioux, which opened up twenty million acres and pushed the Dakota tribes to a small tract of land on the Minnesota River's western edge. The treaty was a contributing factor to the U.S.-Dakota War of 1862.

As soon as Rochester was established, residents focused on finding ways to connect with other communities. Rochester's location amid prairies, bluffs and woods in what was known as the Minnesota Triangle created a hindrance for transportation and communication. Rochester's biggest encumbrance was the lack of a major waterway. While Winona to the east enjoyed the luxury of the Mississippi River and Mankato to the west benefited from the Minnesota River, Rochester's largest river, the Zumbro, didn't have the breadth or depth to accommodate riverboats, which delivered mail, freight and people. However, ambitious entrepreneurs progressed quickly toward a transportation and communication solution.

DUBUQUE TRAIL

New Englander Marion Sloan arrived with her family in April 1856. She was ten years old. In Marion's written recollections, she recalls spending four days on a train before reaching Galena, Illinois, where her family boarded

the steamboat *Alhambra*, journeying two days on the Mississippi River until disembarking in Winona, where Marion's father—who had arrived a year before—met them. Marion described that when she arrived in Rochester, it had "a log hotel, log post office and store and one, two or three log houses and one frame one. We came past the place where the log schoolhouse was being built and my father told us that we would go to school there when the building was completed. It was on the east bank of the river, a little way south of the 4th Street Bridge." Marion remembered bursting into tears when shown the small rustic log cabin they would call home. Marion's sister Elnora stated that Minnesota "was the 'Far West,' the new territory, which had no history, no old times and no traditions save those of the Chippewa and the Sioux."

It was not easy to access Minnesota Territory, and immigrants demanded new land routes. In 1854, Martin O. Walker and John Frink were awarded a U.S. Mail contract for $9,000 a year, running a stage line between St. Paul and Dubuque; the partners operated contracts in eight Midwest states. The first mail delivery left St. Paul on July 15, 1854. Rochester was a designated stop and was platted on July 25, 1854. Covering 272 miles, the trip to Dubuque took four to five days, and stages departed St. Paul on Mondays, Wednesdays and Fridays. The north–south route soon evolved into more than just a mail delivery system. In the February 1960 issue of *Olmsted County Historical Society Monthly Bulletin*, Ernest H. Schlitgus describes the route as "the state's first practical overland artery for commerce and immigration. It cut through fertile farmlands on the north–south line from the busy city of Dubuque to St. Paul, its young neighbor to the north."

The Dubuque Trail was the largest and most traveled route, but smaller routes were established, linking the southeastern and southwestern corners, including a route that went through Rochester, connecting Winona to Mankato. In 1930, Arthur J. Larsen of the Minnesota Historical Society gave a presentation in Owatonna titled "Early Stage Routes and Transportation Lines of Southern Minnesota," in which he described the treacherous trails and how they didn't deter land-hungry pioneers. By 1854, "the outline for the network of roads in the Triangle Region had been completed with four major east and west roads and four north and south roads. Within a short time, all of these became stage routes. Winding and wandering over the countryside, the roads of the fifties served to weld the scattered settlements and to keep the community of interest."

Stage lines spread from Rochester to many Minnesota cities. J.C. Burbank & Company became a fierce rival of Martin O. Walker, who became sole

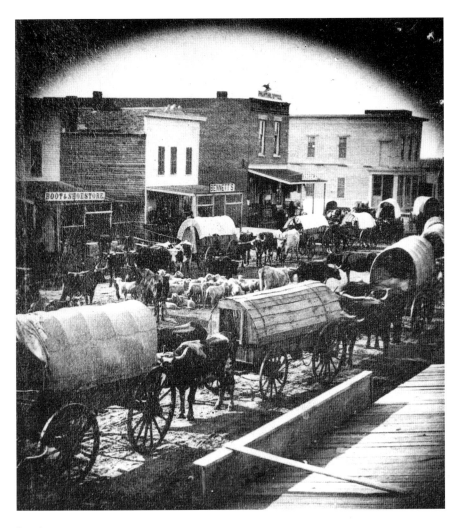

Immigrant ox wagons.

owner of what was once the Frink & Walker Stage Line. The two companies fought for the best and most cost-effective routes between Lake City and Winona to Rochester, and improved roads and lower fares resulted.

By 1857, the eight-foot-wide Dubuque Trail was southeast Minnesota's main stage route. In March 1857, a reporter for the *St. Paul Advertiser* stated:

> The great Dubuque and St. Paul Road passes through Rochester where it is intersected by the principal thoroughfare from Winona westward....In summer, Rochester is sort of a grand encampment for the meeting of streams

of emigration upon both these roads. We counted 100 emigrant wagons last summer…on the outskirts of town, their occupants huddled in groups around a dozen or more fires.

Traveling by stagecoach was not comfortable, especially on the first vehicles to crisscross Minnesota. In a July 18, 1864 article, the *Daily Minnesotan* described the first coach leaving St. Paul for Dubuque as a "sort of antiquated looking vehicle drawn by four lean grays." While this might have been acceptable for mail and freight delivery, it was not long before more luxurious accommodations were requested. By 1861, the famed Concord Coach of the Abbott Downing Company of Concord, New Hampshire, was a regular fixture. According to a 1983 *Goodhue County Historical News* article, there were two styles of Concord Coaches: "the heavy western coach built for mountain travel and the light or eastern model used extensively in Minnesota." The coach's well-received improvements included a window for each door that could be raised and lowered, open panels on the side doors with leather curtains that could be drawn closed, an iron railing on the roof to keep baggage from falling and padded seats. The coaches were

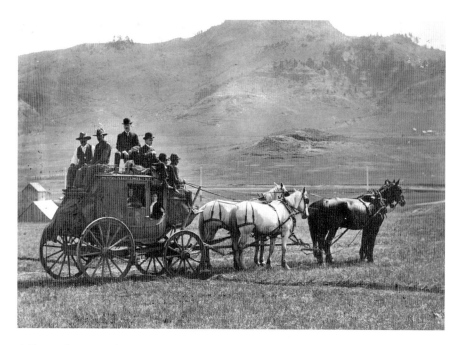

A Concord stagecoach.

also wider and taller. What distinguished the Concord Coach the most from its predecessors was its unique suspension design. The cab rested on two parallel thick leather strips called thoroughbraces that stretched the length of the coach from front to back. The leather bands allowed for flexibility of movement for the stage's heavy centerpiece as it moved across uneven and rocky terrain. It was not stationary. Instead, it swayed from front to back and from side to side. This unique design provided shock absorption for passengers and for the team of four or six horses. It also helped propel the coach forward, easing stress on the team pulling it toward its destination.

With the increasing popularity of travel along the Dubuque Trail, places were needed for overnight stays. Rochester saw its first hostelry erected in 1855, a log cabin built by Albert Stevens. This rustic structure would eventually be called the Zumbro House before being renamed Bradley House. It operated as such for nearly twenty years.

BRADLEY HOUSE

The Bradley House was regarded as one of the best hotel establishments along the Dubuque Trail. This was attributed to the owner and manager, James T. Bradley. Bradley gained a reputation as a well-known and respected hotel proprietor while in La Crosse, Wisconsin. He arrived in Rochester with a vision to make his Rochester hotel a comforting destination.

Bradley House was located at the corner of Fourth Street Southeast and Third Avenue Southeast, which was called Dubuque Street because it was the route the Dubuque Trail used as it passed through the city. Bradley House was in a prime location for servicing the stage line. It would eventually transport visitors to and from the railroad depot by way of an elegant coach. Bradley's three-story structure provided a welcome respite from the bumpy trail. The original log cabin remained, used as a kitchen behind the newer structure. The building was of the New England I-House architectural design, with two chimneys and gables located on its east and west ends. The symmetrical façade of the vernacular building faced south, its front door easily accessible off Fourth Street Southeast, and it possessed a central passage dominated by a staircase with rooms on either side.

Bradley was a charismatic man with a big vision. The *Rochester Republican* claimed on May 4, 1864, that Bradley was "refitting and furnishing it for a first class hotel." The paper followed with a September article announcing

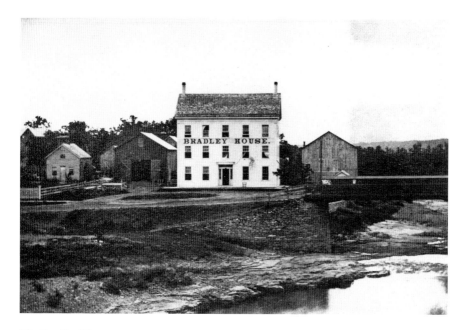

The Bradley House.

the opening of the hotel and that "the house has been finished and furnished throughout in a superior manner and will rank with the first class houses of any of our western towns." The newspaper also complimented Bradley warmly by stating that he "knows how to keep a hotel" and "he has spared no pains or expense to give the proper accommodations." The *Chatfield Democrat* wrote in January 1865 that the forty furnished rooms had "new and stylish furniture" and it was "without a doubt the neatest, most comfortable and best conducted public house in the interior of the State" and that "the gentlemanly and experienced landlord [Bradley], has no superior in his profession." When Bradley died in 1874 at age fifty-eight after a painful and yearlong cancer battle, his August 22, 1874 *Rochester Post* obituary declared that in business, he was "capable, honorable, generous and upright, social and agreeable in manner, and of warm, sincere friendships. But in the home it was, we believe, where the commendable qualities of the deceased shone with their great luster. Warmly attached to home and its associations and ardently devoted to his family, as a husband he was over faithful, tender and affectionate, and as a father, kind, loving and indulgent."

After his death, Bradley's wife and James D. Bradley, their eldest son, took over management and, according to a July 6, 1883 article in the *Rochester Republican*, "conducted the hotel, fully sustaining its excellent reputation,"

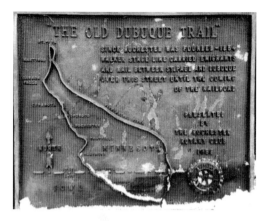

Dubuque Trail historical marker.
Amy Jo Hahn.

until 1880, when James left for Chicago to work for a large grocery store chain. Mrs. Bradley stepped away from management but continued to own the property for several years. A July 1883 fire destroyed much of the building, but W.J. Eaton remodeled and renovated what remained. The Crescent Creamery Company occupied it before another fire destroyed the building in January 1892.

By the time Bradley House met its demise, the Dubuque Trail was already a relic of the past, giving way to the railroads. A paved highway following its general route was named U.S. Highway 52 in 1934. People zip along the highway without realizing the historic route they follow. Rochester residents don't notice the small plaque embedded in a large boulder at 717 Third Avenue Southeast paying homage to the historic trail. The 1958 historic marker reads: "The Old Dubuque Trail: Since Rochester was founded—1854—Walker Stage Line carried emigrants and mail between St. Paul and Dubuque over this street until the coming of the railroad."

RAILROADS

The first passenger train arrived in Rochester in October 1864, traveling from Winona, on tracks laid by the Winona & St. Peter Railroad. Marion Sloan wrote that the two gleaming engines, named the Winona and Rochester, were "beautiful specimens of art."

Rail service to Rochester didn't happen overnight, nor did it come without conflict. Initial work began in 1858 but was derailed a year due to lack of funds. Thomas C. Cummings, a northwest Rochester landowner, was shot

in 1859 due to his protest against the Winona & St. Peter crossing his land. He suffered a bullet to his chest after a confrontation with the rail company's grading foreman, Bill Messler. "There could have well been a lynching, and a menacing crowd did gather," recalled a 1957 *Rochester Post-Bulletin* article, and "he [Messler] was hurried out of town to Winona in a fast team" by local authorities. The land's topography also created challenges. Winona is nestled alongside the Mississippi River, surrounded by beautiful bluffs with hard limestone rock. The route to Rochester, which rests at a higher altitude, was difficult to map due to these natural formations. But the two towns and the Winona & St. Peter were determined to finish the project. Once the train reached Rochester, a regular schedule was put in place. The forty-five-mile journey took about four hours.

The Winona & St. Peter may have operated the first trains, but that exclusivity wouldn't last long. Just as stagecoach companies battled for dominance of transportation routes throughout the 1850s and early 1860s, the same was true for the various rail companies. In addition to the Winona & St. Peter, the Chicago & North Western; Winona & Western; Wisconsin, Minnesota & Pacific; and Chicago Great Western all were major players.

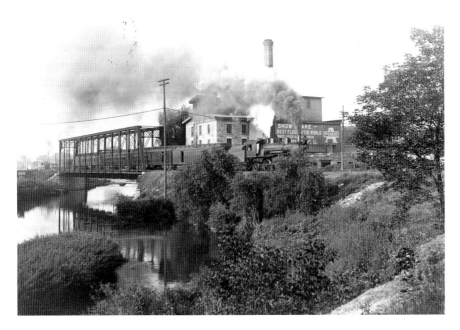

A train along the Zumbro River, circa 1900.

18

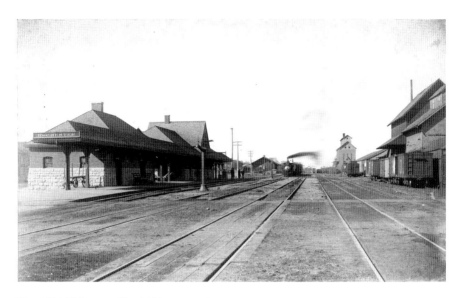

The 1890 Chicago & North Western station.

Railroad lines spread from Rochester, eventually allowing for connectivity to Kansas City, St. Paul, Dubuque and Chicago.

Once established, rail travel went relatively smoothly. However, on occasion the unpredictable weather could be harsh, and railroad employees and passengers faced treacherous conditions, including blizzards that produced twenty- to forty-foot snowdrifts and overflowing waters of the Zumbro River, which flooded and washed out tracks.

The two most remembered railroad companies are the Chicago & North Western and the Chicago Great Western. Each had a station in Rochester. The Chicago Great Western Railroad Depot, first home to the Winona & St. Peter and then the Winona & Western Railroad, was built in 1864 and originally located on Fourth Street Southeast. After purchasing the Winona & Western in 1903, the Chicago Great Western separated the building into two pieces and moved it to 19 Second Street Southeast, where it sat for ninety-four years, experiencing a second life as a bus depot, before returning to its original location in 1997. For several years, it was a Mexican restaurant. It reopened in 2017 as another eating establishment called Porch and Cellar.

The Chicago Great Western Railroad Depot was lucky to survive. The 1890 Chicago & North Western Railroad Depot alongside Civic Center Drive was not. The last passenger train left Rochester from this station

on July 23, 1963, much to the disappointment of Rochester residents, visitors and employees of the Mayo Clinic, who believed the passenger line was important in making lifesaving medical care accessible to patients. Theodore Hanson, heading to Chicago, bought the last ticket from John Liebe. It was the end of the "Rochester 400," a passenger train route connecting Rochester to Mankato and Chicago. This route was part of the Chicago & North Western's "400" fleet, which included various passenger trains that serviced large and small cities throughout Illinois, Wisconsin, Minnesota and, for a time, South Dakota. The routes were nicknamed the "400" because the first route launched in 1935 was dubbed the "Twin Cities 400" and it claimed to cover four hundred miles in four hundred minutes as it delivered passengers from Minneapolis to Chicago. Two years later, the Chicago Great Western and the Chicago & North Western, longtime rivals, merged and began operation under Chicago & North Western. The depot met the wrecking ball in 1989.

THE RED AND BLUE BIRD

Although passenger rail service to Rochester has been obsolete for five decades, there was a time when two luxurious streamlined passenger cars traveled directly to the Twin Cities: the Red Bird and Blue Bird.

While in operation, the Red Bird and Blue Bird locomotives were a sight to behold: gleaming iron machines of bright red and blue rumbling at fast speeds through the landscape's dense woods, alongside its abundant rivers and across its vast farmland.

The Red Bird ran from about 1920 to 1925, and in its five years of service, it covered a total of 390,000 miles and carried 560,000 people. It provided nonstop service and often traveled 60 miles per hour. An October 21, 1957 *Rochester Post-Bulletin* article said it was "considered the fastest and fanciest train of its day between Rochester and the Twin Cities," and "its colorful red and gold engine and cars speeding through the countryside was a thrilling sight." *The Chicago Great Western in Minnesota* states the Red Bird was quite impressive: "The Great Western streamlined a steam locomotive, a fast Pacific-type, and then had it painted a vermillion red with gold wheel spokes. The cylinder heads and rods were polished to a high gleam. The four coaches were also painted red with gold stripping and gold lettering decorating the sides of the coaches."

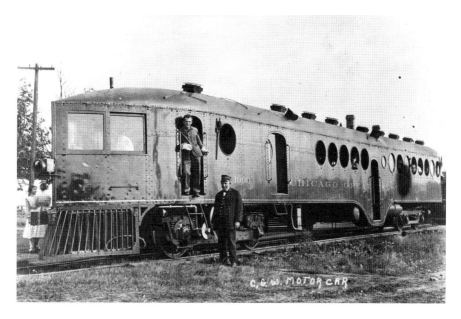

The Blue Bird train was built from this motor car.

After leaving the Great Northern Station in Minneapolis, the Red Bird traveled over the Mississippi River's Stone Arch Bridge toward St. Paul's famed Union Depot before turning south and heading to Rochester. The train departed the Twin Cities at 9:45 a.m. and arrived in Rochester at 12:05 p.m. It departed Rochester at 4:00 p.m., arriving in the Twin Cities around 6:45 p.m.

The sister to the Red Bird was the Blue Bird. It stopped in several small towns along the way to Rochester. *The Chicago Great Western in Minnesota* gives a detailed description of the Blue Bird:

> *The motor was a 300 horse power six cylinder gas engine with electric transmission built by Electric Motive. The motor car also included a baggage and mail room. The first coach in the train was decorated in shades of blue with deep plush seats, wide aisles and seating for 75 people. The last car was a parlor observation-club car featuring grey-blue carpet, mohair blue upholstered chairs, and two complete Pullman units designed for people who were traveling to Mayo Clinic. The train was painted a rich blue with lettering in gold.*

The Blue Bird arrived on the Chicago Great Western tracks in 1929 and provided passenger service until 1931. With its demise, the golden age of passenger service from Rochester to the Twin Cities came to a close. Today, the only locomotives traveling through Rochester carry freight and are operated by the Dakota, Minnesota and Eastern Railroad.

ROOTED IN AGRICULTURE

Decades before people flocked to Rochester to work and receive medical care at Mayo Clinic, people arrived in Olmsted County dreaming of landownership and prosperous farming. Even hospitals were involved in farming. Saint Marys Hospital had a small farm on its south side before purchasing a larger farm on the western edge of the city. Rochester State Hospital owned and operated a five-hundred-acre farm on the town's eastern edge. Today, small rural communities whose economic vitality is entwined with the annual autumn harvest border Rochester. And once upon a time, agricultural was Rochester's main industry.

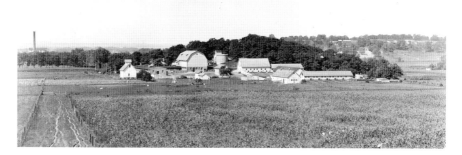

Rochester State Hospital's farm.

STATE AND COUNTY FAIRGROUNDS

Rochester held the first Olmsted County Fair in 1860 over the course of two days, October 3–4, at the city's first designated courthouse, Broadway House. Before the fair could build momentum, the Civil War started, pausing it for the next four years.

In the midst of starting an annual county fair tradition, Rochester found itself in contention to host the Minnesota State Fair. This was due to its rich agriculture environment. The Minnesota State Fair in St. Paul is known today as one of the best state fairs in the country, regularly taking the top spot in national polling lists. However, for a while the fair bounced back and forth among Minneapolis, St. Paul, Rochester and three other cities in southeast Minnesota farm country: Red Wing, Winona and Owatonna. Rochester hosted the state fair in 1866, 1867, 1869, 1880, 1881 and 1882. On the years the state fair was held, the county fair was not; all effort was put toward hosting the best state fair.

Rochester and the surrounding communities were excited about the first state fair. There was much interest expressed in the months leading up to the October state fair, and newspapers printed stories about preparations at the fairgrounds, located in the south part of the city now occupied by Soldier's Memorial Field. The land was owned by Charles Morton and would eventually pass into the hands of W.W. Ireland. It was chosen because it already possessed a popular horse racetrack. "The track has been widened and leveled and will by the first day of the fair, be finished and in first rate order," wrote the *Rochester Post* on September 22, 1866. "The enclosure of 60 acres is entirely fenced....The fence extends around three sides, the fourth being formed by the river. It makes a very commodious enclosure and the river furnishes an inexhaustible supply of that prime necessity of such occasions, water." Harness racing was an incredibly popular fair event during the later half of the nineteenth century and into the early twentieth century. Many Rochester residents owned, trained and raced horses.

The *Rochester Republican* recorded that between eight and ten thousand visitors enjoyed opening day. In *Highlights of the Olmsted County Fair*, Ray Aune wrote, "The people of Minnesota came by train, by wagons, on horseback and on foot to view exhibits, which ranged from horses to gooseberry jam. They watched the horses racing madly around a dirt track; they stood for hours listening to never ending political speeches and mostly, like today, they ate and ate." The *Rochester Republican* gave

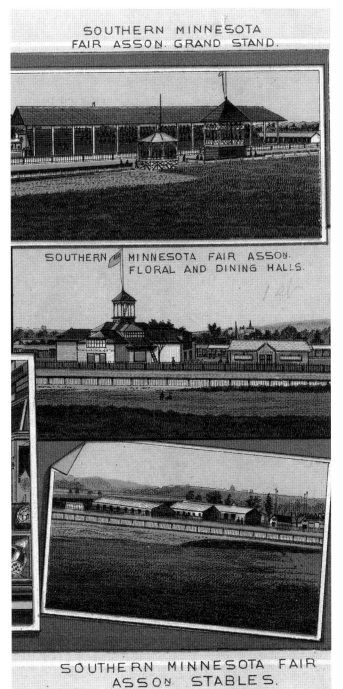

Southern Minnesota Fair Association's grandstand, floral, dining halls and stables.

One of blacksmith Charles Cresap's prized racers, circa 1890.

great descriptions about many exhibits, including a Mechanics Hall that showcased "several styles of weighing scales, carriages, sleighs, harness and saddler, washing machines, churns, patent bag-holders, a fine example of Minnesota finished leather" and the Floral Hall with its "array of pictures, millinery embroidery, pen-drawing, wax fruit and flowers," which "is very extensive and manifests much skill and perseverance in the cultivation and practice of the fine arts."

The newspaper also raved about the agricultural implement show, with "several styles of threshing machines, tanning mills, plows, cultivators, seed sowers and harrows, besides a good show of farm wagons." Farm produce and livestock were on exhibit. There was also a competitive plowing match, but it failed in comparison to the anticipated horse races. It was, the newspaper proclaimed, "the leading specialty of the Fair." Star of the West, owned by John Grosbeck of Rochester, was a top attraction and won his three races. Despite the thrill of the races, the gathered crowd bore witness to a sad occurrence. A race between Kitty Miles and Sleepy David ended in tragedy. Sleepy David, reported to be ill, lagged far behind for the entire race, dying as he crossed the finish line.

The state fair was an even larger success in 1867, growing to eighty acres with larger building spaces and an additional racetrack. Rochester

was gaining a reputation as a horse-racing destination and was often called the "Lexington of the West." There was a desire to host the fall event more often, possibly permanently. The Southern Minnesota Fair Association was formed to promote Rochester as its possible home, but in 1885 that honor went to Ramsey County in St. Paul, which was more centrally located. With the loss of the state fair, Rochester turned its focus to expanding the Olmsted County Fair.

For many years, the Southern Minnesota Fair Association leased the fairgrounds. In 1882, it purchased the acreage for $20,000 and used it for the next eight years. Horse races continued to be the highlight of the fair, but in 1888, the fair association decided to try something unique to attract fairgoers. It held the Matrimonial Happiness Contest. The winners were Mr. Thomas James Elford and Miss Adeline Postier. The September 4 wedding on the racetrack was quite the spectacle. The *Rochester Post* reported that 1,500 people were in attendance, and a band led the bridal procession. The bride and groom exchanged vows under a canopy of white gauze and flowers on a pavilion placed in front of the grandstand. Rochester businesses closed for the day, and several gave gifts to the newlyweds. Although publicity stunts like this helped entice crowds to the fair, they were not enough to keep the Southern Minnesota Fair

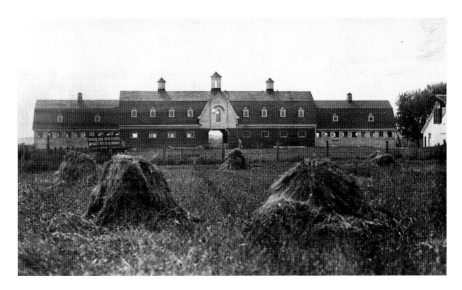

Dr. Christopher Graham's horse barn; it stands today, converted to business space.

Association out of financial trouble. The county was asked to purchase the property. County residents voted on December 5, 1899, against the proposal, not wanting to raise taxes to fund the fair. W.W. Ireland bought back the property for $6,425. The Southern Minnesota Fair Association was defunct by the end of 1900.

After renting the fairground property for ten years, the county received an offer from Mayo Clinic physician and veterinarian Dr. Christopher "Kit" Graham, a prominent fair supporter, to lease his land for fair use. Dr. Graham and his wife, Elizabeth Blanche Brackenridge, lived on her family farm, across the road from the original fairgrounds. Dr. Graham's passion was agriculture, especially livestock. When he retired from Mayo Clinic, he pursued his livestock interest: raising Holstein-Friesian cattle, Percheron horses and Orpington chickens. When, in 1910, the Grahams purchased an additional 160 acres on the southern edge of their property, they decided to offer 60 acres for purpose of the fair. The county accepted, and several buildings were built on the property over the next nine years. In October 1919, the Grahams donated the 60 acres to the Olmsted County Fair Association; the county fair is still held at that location, with its main entrance along South Broadway.

In 1919, Dr. Graham donated land for the Olmsted County Fairgrounds.

OLDS & FISHBACK AND COLE'S MILLS

According to the *History of Olmsted County 1910*, during the years between 1856 and 1885, "Rochester was the greatest wheat market of Southern Minnesota, which was the wheat region then, in fact, of the state." The abundant wheat production created a need for constructing gristmills to process the crop.

Frederick A. Olds moved to Rochester in 1855 and set upon constructing a mill. Finished in 1857, the three-story stone building was forty-six feet by seventy feet with walls five feet deep. It cost $40,000. It was often called the "Stone Mill" or "Rochester Mill," but its official name would become Olds & Fishback. The mill was located at Third Street Southeast along the Zumbro River's west bank. The Chicago Great Western Railroad tracks would eventually run past it. A man-made canal allowed the swift current of water to flow from the river to the mill, moving the mill's wheel and delivering valuable power needed to operate the grinding machinery. This water detour was known as a millrace.

Olds, often called "Judge" because of his law education and background, died in 1864 at age fifty-four, his death attributed to internal injuries he sustained after falling while inspecting a home addition on his farm ten miles west of Rochester. The *Rochester City Post* expressed hope for one of its most well-known businessmen, writing of the accident on August 6, 1864: "At last accounts he was doing well and able to walk a few steps. The Judge's escape was a narrow one, considering his weight—over two hundred pounds—and the distance he fell—eighteen feet; but having a vigorous constitution he will doubtless recover in a short time."

After his death, his son, Frederick Olds Jr., and son-in-law, T.L. Fishback, took over, running a successful mill for several years. They were known as being adaptable business owners, and an October 2, 1875 *Rochester Post* article highlighted several mill improvements:

> *They have taken out some of the water wheels and now run four run of burrs* [stones used to grind grain] *with two wheels, instead of the three that they have heretofore used; making a saving of twenty per cent in the amount of water used. A new elevator and conveyor to carry the flour from the stones to the bolts have been put in, with an exhaust pan attached, to cool the flour before passing to the bolt* [sifter or separator]*. The old bolts have been taken out and a new bolting chest put in with six entirely new reels of bolting. An entire new upright*

shaft and new machinery attached to it [to move the stones] *have been put in.*

The new equipment had a price tag of $3,000 and was thought to "greatly facilitate the business of the mill and will especially improve the grade and quantity of flour manufactured, making better flour and more of it." In December 1882, the *Rochester Post* reported that the mill received "100,000 bushels of wheat; of this, about two-thirds has been manufactured into flour for shipment and retail trade," and the mill's steam engine hadn't been used the entire year because of a high water supply. Fishback left the business in 1882. In 1883, Olds and his wife, Angelina, sold the business to John A. Cole, leaving Rochester for Tacoma, Washington, where Olds died in 1900.

For John A. Cole, milling was a family business. His father, John M. Cole, bought Zumbro Mill in 1864; it would become known as Cole's Mill. The wood mill was located between Seventh Street Northeast and Eighth Street Northeast where the south fork of the Zumbro River met the Silver Creek channel at the southeastern edge of Silver Lake, which didn't exist until 1936. The mill was destroyed by fire in 1878. At the time of its demise, it was an impressive structure. According to the December 27, 1878 *Rochester Post* article written about the fire that destroyed the mill, Cole made many improvements, adding fifteen-foot-wide additions on each side in 1865, raising the foundation six feet and putting in a stone foundation to keep it dry from flooding waters and adding a new water wheel, new millstones, bolting chests, shafts, gears, new elevators, an additional floor and a steam engine for power use when the river was low. The same article described the lost city landmark in great detail:

> *The extreme size of the mill is 60 x 40 feet, and including the basement, it was four stories high. It was a wood structure and from the base of the foundation wall to the peak of the roof it was eighty-five feet. On the north side there was an elevator 26 x 26 feet in size and sixty-five feet in height, making the extreme front of the structure eighty-six feet.... This structure had an elevating capacity of seven hundred bushels per hour, and a storage capacity of twenty-two thousand bushels.*

Rebuilding started in the spring of 1879 and was finished in early winter 1880. When the 1883 cyclone ripped through the city on August 21, the mill received its brunt force and was severely damaged. John M. Cole

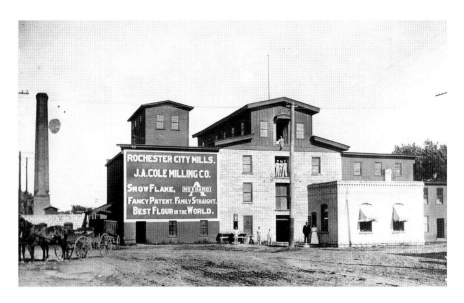

John A. Cole Milling Company's Rochester City Mills.

died while heading home. Rochester citizens had the highest regard for him as a community member. His *Rochester Post* obituary read, "He will be remembered not so much for his business career which was successful in the best and highest sense, as for his genuine unobtrusive piety and benevolence, which, although working quietly like the sunshine, carried comfort to many homes and helped many hearts."

The mill burned to the ground in May 1890, but a new three-story mill was built in its place. The *Post & Record* in 1902 called John A. Cole an "enterprising proprietor" and "a gentleman to deal with." By 1905, Cole had formed the John A. Cole Milling Company, under which Zumbro Mill and Rochester City Mills (Olds & Fishback) were operated. In 1910, the company became the Rochester Milling Company. Cole sold the company in 1920 to William H. Knapp and moved to California, where he died in 1930. The city took over ownership of the old Olds & Fishback property about ten years later, and a General Mills Farm Service Store rented the space before the north part was torn down in 1951 and the rest in 1953. The fate of Zumbro Mill, smaller and less prominent, is not as well recorded, but it no longer exists, eventually stopping operation and falling into ruin, disappearing from the city landscape.

CASCADE (TONDRO) MILL

Another busy mill was located in northwest Rochester. Cascade Mill was situated not far from where Cascade Creek meets up with the Zumbro River, along Third Avenue Northwest where Thompson Mill Race Park is now located. People walk, bike and jog past its ruins every day, many not realizing the structure's historical significance. Just west of the Cascade Mill site, on the opposite side of Third Avenue Northwest, is Indian Heights Park. Perched on a bluff with views of Zumbro River, it's believed to have once been a Dakota burial ground. In the winter of 1854, two hundred Wahpekute Dakota made camp along the Zumbro River for several weeks. An unidentified illness swept through the tribe, and not all survived. The *History of Olmsted County 1883* recorded, "The bodies were buried on a bluff nearly west of the site where the Cascade Mill now stands. There were, in all, eight bodies of the deceased Indians buried there, and the spot has ever since been known as the 'Indian burying-ground.'"

John S. Humason and Gilbert Smith built Cascade Mill in 1864, securing water rights for Cascade Creek. The *Rochester City Post* reported on May 14, 1864: "Among the many improvements now going forward in our busy little city, we are gratified to learn of one enterprise recently undertaken by Humason and Smith, of this place, which must provide of great benefit to the city and to the entire surrounding community." Humason eventually became sole owner of the mill and sold it to Lewis Harkins and Abraham Harkins in 1867. The brothers made it larger and added new machinery and a new water wheel. In 1871, Lyman Tondro bought the mill and owned it until it closed in 1902. Clarence Thompson bought the mill site in 1903, and the Thompson family owned the property for eighty-three years until donating it to the city for use as a park.

Tondro, a Civil War veteran, was an active member of the community, serving six years as alderman for North Rochester and postmaster from 1889 to 1894. Cascade Mill had two burr runs, one for flour and one for livestock feed. It was a large three-story frame building with one-and-a-half-story wings on either side. Between 1877 and 1879, Tondro added a fifty-horse steam power to the already existing water power. A one-story building, about fifty feet to the west of the mill, was built to house the steam engine boiler. It had six-foot-high door openings with an opening of twenty feet by twenty feet, which accommodated moving large boilers. A *Record & Union* article from April 1875 stated, "No mill in the city puts a better grade of flour in the market than the Cascade." In the *History of Olmsted County 1910*, Tondro was

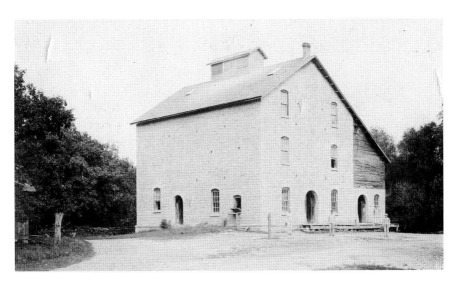

Cascade Mill was rebuilt after the 1883 cyclone.

described as a man "wounded in battle by a shot through both hips, from which he never recovered and often he experienced much suffering, but was usually active and energetic in business."

The infamous 1883 cyclone severely damaged the mill, but Tondro rebuilt it and operated it until his deteriorating health forced him to sell it to Clarence Thompson. After sitting vacant for decades, the old mill succumbed to several fires, which destroyed it beyond possible renovation or rehabilitation.

ROCHESTER IRON WORKS

By the late nineteenth century, the city's mills had at least one steam engine used for backup in case water power supplied from the river was weak or nonexistent. But that wasn't the only use for the large machines. Steam engines became an essential harvesting tool for the farmer, a common fixture on rural farms. Charles Allaire, Edward Chapman and William Purcis saw a lucrative business opportunity and were the first owners of Rochester Iron Works. Built in 1865, the business included a machine shop and foundry and was located in the vicinity of First Street and First Avenue Southwest.

In the 1871 *Rochester Business Directory*, an ad for Rochester Iron Works highlighted some of its services and products, including having iron founders and machinists and dealing in millstones, bolting cloths and separators. The ad also stated, "We manufacture and repair steam engines, mill machinery, threshing machines, horse powers, iron railings…and iron and brass castings of all kinds."

A June 25, 1881 Rochester Iron Works receipt lists the company's services on the upper left side, which included "grain elevator machinery, boilers and engines, horse powers, shafting, pulleys, hangings, Monarch windmills, iron and wood pumps, iron and brass cylinders, pipes and fittings and iron and brass castings." The same receipt shows a purchase for one Monarch windmill for fifty-five dollars. Rochester Iron Works also sold three hydraulic elevators to Rochester State Hospital and one to Schuster Brewery during the early 1880s. A receipt dated 1896 charged four dollars for placing two hitching posts.

Dexter Livermore bought the business in 1869. His son Fred took over in 1873. In 1902, Livermore sold the business to George M. Marquardt Jr. and Howard Lull. The men decided a larger facility was needed. They purchased property and erected a larger building and foundry at Second

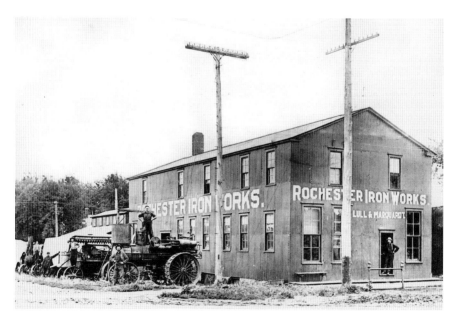

Rochester Iron Works produced steam engines and grain-elevating machinery.

Street Northeast, just off Broadway near the Chicago & North Western rail tracks. Lull exited the company and moved to North Dakota in 1909. Fred Ormond became a vested partner and contributed his knowledge in contracting for roads and bridges. Marquardt worked at the shop as a machinist, an expert in shaping wood and metal. The *Olmsted County Democrat* reported in a June 4, 1909 article that "both members of the co-partnership are thoroughly reliable and highly respected men and there is no doubt of the interesting prosperity of the business as time goes by."

When Ormond died on February 12, 1931, his wife received his half of the business. H.E. Swenson bought the small tools division of the company. When Marquardt died on October 2, 1938, his brother inherited his share, which was transferred to his wife upon his death. The buildings were rented to Swenson until his death in 1955. His small tools business was sold to Roy Crowson and Robert Sill. After Swenson's death, Mrs. Ormond and Mrs. Marquardt sold the property and buildings to Harold Dison. The 1902 buildings were razed in 1957. The original buildings of the Rochester Iron Works were sold to the Chicago Great Western Railroad and demolished.

ROCHESTER WOOLEN MILLS

In 1896, C.T. Booth approached the city about building a woolen mill. A fire had recently destroyed his woolen mill in Chatfield, a town twenty miles southeast of Rochester, and he wanted to rebuild in Rochester. In November 1896, city officials met with interested citizens to share the results of an investigation into whether a woolen mill would be a positive boon. According to an unidentified newspaper clipping in the archives at the History Center of Olmsted County, the results were favorable, and it was agreed this was an industry "Rochester cannot afford to lose. It will create a good market of wool grown in this county and will be a stimulus to the wool grower, as better prices will prevail since the manufacturer in this county can afford to pay a fair price for wool." Approval was given to permit construction.

Rochester Woolen Mills was completed in 1897. Designed and built by John M. Doherty, it neighbored Cole's Mill (Zumbro Mill) near the Zumbro River and Silver Creek at 702 West Silver Lake Drive Northeast where the historic 1950s-era Silver Lake Fire Station No. 2 is located. A January 15, 1897 article in the *Record & Union* gave a description of the new mill:

The building will be three stories high, with an attic, the main part being 50 x 74 feet. On the north side the drying room will be situated, and this will contain the coloring vats, a large tank underneath supplying the water. South of the large building a smaller one, of brick and stone, will be erected, in one room of which will be situated the boiler and engine, and in another apartment the picking will be done. Over the boiler room will be the drying room. This building will be 21 x 50 feet. In the main structure the first floor will be devoted to the finishing, storing and shipping of goods. The weaving will be done in the second floor, the carding and spinning will be done on the third floor, and the fourth floor will be used for drying the finished cloth.

Many local businessmen invested in Rochester Woolen Mills, and when the equipment was turned on for the first time during a demonstration on May 14, 1897, there was great hope the mill would be successful. The *Rochester Post* declared, "The day of progress is at hand; the wheels of enterprise have begun to turn, and it is only a question of a few short years when Rochester will compel recognition as a manufacturing and railroad center." Those high hopes were nearly dashed when a vicious fire erupted in the new mill on the night of July 24.

The fire alarm bells rang loud and shrill shortly before 9:00 p.m. that summer night as red-gold flames illuminated the darkening skyline. Two fire companies arrived to do battle. The *Rochester Post* described how "Hose Company Number 1 made a desperate run down Main Street, and many who saw the team tearing along the street, declared that at fires they had seen here and elsewhere they had never witnessed such speed; the horses fairly flew, seemingly inspired with the fact that the woolen mill, one of the dearest industries in this city, was in flames." The firemen worked frantically to stop the growing fire. It seemed to everyone that it was a worthless fight. However, the firemen didn't give up. They hurried a hose to the nearby Cole's Mill and hooked it up to the mill pump. This gave them a second source of water, the first arriving through eight hundred feet of hose hooked to a hydrant on Broadway. The *Rochester Post* reported:

In a short time two more streams of water were playing upon the red demon…and after a half hour's work the fire seemed to be under control. But it was smouldering in the attic, having gradually worked its way up the long staircase. The flame then burst out again through the attic windows

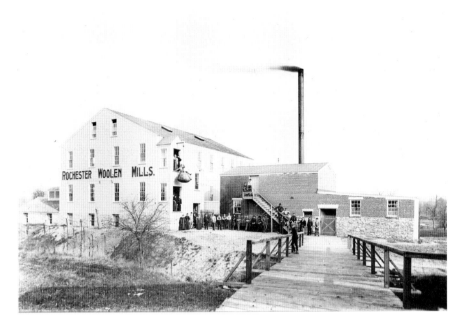

Rochester Woolen Mills made blankets and clothing.

of the drying-room and leaped and roared with redoubled fury. Soon the red fury was brought under subjection, but it was nearly midnight when the fire companies left. The large building from apex to foundation stone had been soaked with water and the greater part of the building had been more or less burned.

The fire was a major setback, closing the business for over a month, but Booth had it up and running again by September, also constructing a one-story warehouse with a measurement of sixty-four feet by twenty-eight feet. A short bridge crossing the millrace connected the new addition to the main building.

For the first two years of its existence, Rochester Woolen Mills produced high-quality wool blankets. Two styles, the Queen City and the Zumbro, one a solid color and the other striped, were manufactured. The product names were inspired by the Zumbro River and Rochester's earliest nickname, Queen City, a term first used by Delbert Darling in an advertisement promoting his Darling Business College. The Rochester Woolen Mills was a success under Booth's management, and growth was inevitable. By 1899, it produced flannel dress goods. A May 26, 1899 *Post*

& Record article stated that one thousand yards were produced daily, and "the particular flannel dress goods made here, which are meeting with so much favor, are those having the cassimere finish and are light weight. They are made plain, in checks and stripes in a variety of colors, and the finish given them could not be finer."

By 1900, Booth had resigned his post, moving from Rochester. H.K. Terry took his place and introduced Made-at-the-Mill trousers, which proved quite popular. To keep up with the demand, a new factory was built on Fourth Street Southeast. A 1901 company advertisement proclaimed:

> *The cloth is made in our woolen mills, and the entire process of manufacture from the sheep's back to the finished garment is carried on in our own clean, well lighted and properly ventilated factories at Rochester, Minn. The seams will not rip. The buttons will not come off. They look and wear well. They are guaranteed to be the best trousers in the world for the money.*

For all its acclaim, Rochester Woolen Mills never fulfilled its promise and closed its doors in 1903. Reports indicated poor management led to its demise. In 1904, the machinery was sold to Braden Woolen Mills of Braden, Oregon, and shipped out on large railroad cars. The buildings were demolished in 1909, but the ghost of its daily whistle remained, reminding Rochester of a lost icon. An October 22, 1897 *Rochester Post* article described its noon song:

> *There was a perceptible ring of pride in the screech of the shrill summons to labor, an arbitrary thrill which seemed to imply: I am the mouth piece of Rochester's principal industry. I speak every noon from the depth of my throat of enterprise, of business, of progress. I am an inspiration to the Queen City. I have awakened her business men from the dull stupor that has settled over them, and the bright sun of enterprise shines abroad in the land, and prosperity is here.*

SCHUSTER BREWERY

Blacksmith Henry Schuster and his wife, Josephine, moved to Rochester in 1863, buying interest in Adam Drescher's Union Brewery in 1866. The brewery, which produced alcoholic beer as well as "near beers" (beverages with no alcohol), was soon a booming business and an important contributor

to the success of the local farmer. Barley was needed to create malt, beer's main ingredient, and barley grew well in Minnesota. In 1870, Schuster became sole owner of the twelve-year-old brewery, starting an iconic family business that would last five decades.

When the original one-story building burned down on April 25, 1871, Schuster wasted no time ordering construction to commence on a new building. The facility cost $5,000 and was forty feet by forty feet and three stories high. A storeroom, a near beer room and an office were on the first floor. The second floor was used for drying malt and had eight-foot-high ceilings. The third floor consisted of an elevated loft with windows on either end that could be opened for ventilation. According to a May 13, 1871 *Rochester Post* article, every effort was made to fireproof the facility, including a separate building of solid brick for "certain furnaces and the heating apparatus of the establishment." The forty-foot by fifty-foot building was constructed to the east of the main structure and was twelve feet high. Schuster ordered eighty thousand bricks for use in the walls from the Whitcomb Brothers of Rochester.

Schuster built a forty-four-foot by seventy-foot two-story addition in 1877 that included Schuster's Hall, a space that provided community organizations a place to gather for meetings and events. Schuster was actively involved in Rochester. The *History of Olmsted County 1910* describes him as being "very enterprising, liberal, generous, and public spirited." In addition to providing jobs, he served four terms as city alderman. Top among his passions was the development of a fire department, using his own money to purchase more water hose.

Schuster was fifty when he died in 1885, and the entire city mourned his death. People lined the streets to watch his funeral procession as it went down Broadway and traveled to Oakwood Cemetery on the east side of the Zumbro River. A city band participated, and members of the fire department marched behind his hearse. It was a demonstration of respect and admiration for one of the city's most important and influential men, an immigrant boy born in 1835 in Prussia (Germany) who had achieved the American dream.

By the time Henry Schuster died, the brewery was producing two thousand barrels of beer a year. It was also the only brewery in the city; its two competitors, Cascade Brewery and City Brewery, were shuttered by 1882. Schuster's sons, Henry Jr. and Frederick, continued their father's entrepreneurship. A popular brewery product tradition was its German-style bock beer. The eagerly anticipated dark beer was brewed in the fall,

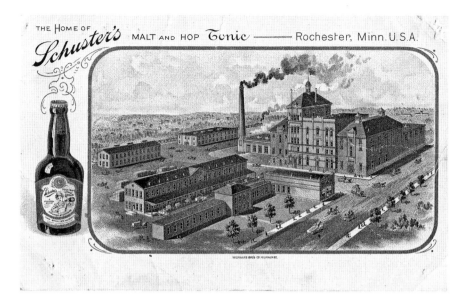

Schuster Brewery closed in 1922.

stored through the winter and consumed in the spring. Due to its limited availability, a spring celebration heralded its public release. A *Rochester Post* article from May 20, 1887, stated that "the Union Brewery celebrated the bock beer season last Saturday [May 14] by a procession consisting of their delivery wagon fitted up in good style with patriotic platform draped with national colors….The equipage was drawn by four black horses driven by Charley Jackson, resplendent in a stove pipe hat and ample shirt front. It was a parade to delight the heart of the thirsty." The brothers continued making nearly yearly improvements to the brewery, which included expanding existing buildings, erecting additional buildings and purchasing new equipment. But probably one of their most important contributions to the brewery's continued prosperity was their interest in creating new products.

Schuster Brewery's Pure Malt & Hop Tonic was introduced in April 1897. Similar tonics, marketed as medicinal, enjoyed great popularity across the country. The Schuster brothers saw a chance to capitalize, especially since Rochester was gaining a reputation as a reputable medical city. The *Rochester Post* announced its upcoming release in a March 19, 1897 article, stating that the tonic was "made from the best quality of malt and hops, the choicest barley malt and imported Bavarian hops entering into its composition." The article commended the brewery on being "a progressive institution" and

stated that the brothers' products "need no introduction to the public as they speak for themselves and appeal most eloquently to the taste of those who have tried them and have no case found them wanting." In addition, the article declared the new product was "pronounced by the medical fraternity of Olmsted County to be par excellence as a tonic and is used at Saint Marys Hospital….It is, in fact, used exclusively by them and is regarded as having no superior." The demand for the new product created a need for a new building. The thirty-foot by seventy-foot building was made of stone, brick and iron, and the brothers spent $10,000 on installing the most modern bottling equipment available.

In 1898, a new brew house and a cold storage building were added to the brewery complex. An August 19, 1898 *Rochester Post* article stated that the building was "corresponding in style of architecture to the new brew house and bottling building. Steel, stone and brick enter into its construction, steel beams being a great feature. The walls will be two feet thick, with two air spaces." High stone arches graced the first floor. The new structure cost $7,000. Henry Jr. and Fred didn't stop there. An October 7, 1898 *Rochester Post* article claimed the Schusters paid $6,000 for vacuum tanks, which would give the brewer the ability "to turn out his liquor in the best condition in seventeen days. The new way is much superior to the old, because by its use, twice as much beer can be brewed at once as in several times by the old process." The beer produced with this new system was called Vacuum Brau and was available on local taps.

With the new century on the horizon, the Schuster brothers decided it was time to officially change the brewery's name to reflect their family's ownership. Union Brewery became Schuster Brewery in 1899. In 1900, their revolving Schuster Patented Bottle Truck and Drainer, made by W.H.L. Donaldson, was marketed to other breweries. Schuster's Brewery flourished, and additional room was needed. Doug Hoverson writes in his book *Land of Amber Waters: The History of Brewing in Minnesota*:

> *The final chapter in the expansion was the construction in 1905 of an all-new five-story brewhouse along with additional storage, cooperage, and mechanical facilities. The building, designed by renowned brewery architect Richard Griesser of Chicago, followed the gravity plan in which the raw materials began on the top floor and descended from the malting to boiling and finally to fermenting. An interesting blend of new and old technology was represented in the new outbuildings—one was a coal storage room capable of storing ten railcars of coal for the boilers, another was an*

extensive new barn for the Schusters' prize teams of horses. The new addition represented an investment of more than $50,000 and resulted in an imposing structure that would be one of the main features of the Rochester skyline for several decades.

By 1910, the company was producing ten million bottles of beer and tonic a year, which were shipped to twenty-three states. The massive brewery complex, one of Rochester's largest employers, at the corner of First Avenue Southwest and Fourth Street Southwest, constantly evolving and growing since the Schuster family's ownership, permanently stopped operation twelve years later. The cause for its demise: the Eighteenth Amendment. With Prohibition, it became impossible for Schuster Brewery to stay in business. The Schuster brothers tried to make a business on near beers alone, but it was unsuccessful. In a November 4, 1921 *Post & Record* article announcing the closure, Henry Jr. explained why the business couldn't continue: "The serial beverage manufacturing companies [like Schuster Brewery], making soft drinks containing a low alcohol content, cannot compete with the 'kitchen' breweries manufacturing real beer containing from 4 to 10 percent alcohol."

Fred blamed "the women of the country," referencing the Woman's Christian Temperance Union's movement and its influence on making alcohol illegal. On January 1, 1922, the brewery closed its doors. Henry Jr. and Fred Schuster went into the real estate business and did not jump back into the beer business when Prohibition ended a decade later. But by that time, the old brewery was home to another business.

ROCHESTER DAIRY COOPERATIVE

The Rochester Dairy Cooperative had its beginnings at Dr. Charles Horace Mayo's Mayowood Farm, which comprised three thousand acres on Rochester's west side. Jim Punderson was the farm manager, overseeing milk production and its subsequent delivery to thirty-eight customers. A team of mules pulled the milk delivery wagon around the city. In a 1998 biographical history located in the History Center of Olmsted County archives, one-hundred-year-old Alzina Jackson, whose husband milked Mayowood Farm's Holstein cows, recalled helping bottle: "We poured it into bottles, after straining it through white material, out of a pitcher. It

would foam up and we'd await to pour more in. When a bottle was full, we could cap it.…I remember the cream that rose to the top and how amazed we were at the amount of cream." In 1925, Punderson and Dr. Mayo formed a partnership and a business called Mayowood Farm Dairy. During the 1920s, advocacy for pasteurized milk gained momentum and, with it, a need to create processing facilities separate from farm milk production. Because of this need, Mayowood Farm Dairy merged with Rochester's Supremacy Dairy on November 1, 1925, creating the Rochester Dairy Company. The consolidated company needed a place to house its milk processing operations. The Schuster Brewery complex proved to be the perfect location.

Rochester Dairy Company proceeded to create new products, including sweetened condensed milk in 1926, fluid cream in 1927, ice cream in 1931, an ice cream mix and chocolate drink mix in 1933, mission orange in 1935 and tomato juice in 1937. On April 27, 1938, the *Rochester Post-Bulletin* mentioned the company as "one of the leading producers of condensed and powdered milk in the United States" and stated that many favorite candy bars were covered in a milk chocolate covering made exclusively from the company's condensed milk, which was "made solely for industrial uses…sold by the barrel to bakers, candy makers and ice cream makers." Three million pounds of sugar went into making the condensed milk, and it was shipped in "double-lined wooden barrels, holding 650 pounds each." This national success helped the company reach $1 million in sales in 1937. Chocolate bar companies weren't the only high-profile customers. Continental Baking Company purchased Rochester Dairy's powdered milk for its popular pre-sliced white Wonder Bread.

The Rochester Dairy Company purchased the H&H Dairy Company in 1937. H&H Dairy traced its beginnings to 1865, when S.B. Hall started dairy operations on his 203-acre farm on the west side of the city. His son, Arthur J. Hall, moved the business to the city in 1918 and partnered with A.A. Hicks in 1919. At the time of the sale, the Hall family still owned and operated the company. Rochester Dairy also bought the Queen City Creamery Company that same year.

In the beginning of 1942, the Rochester Dairy Company became the Rochester Dairy Cooperative. According to a November 20, 1957 *Rochester Post-Bulletin* article, the need for a cooperative arose because "area farmers were capable of producing an abundant supply of milk but the scattered small dairy plants in the area lacked facilities for drying the milk in large volume." A new centralized cooperative processing plant would "furnish

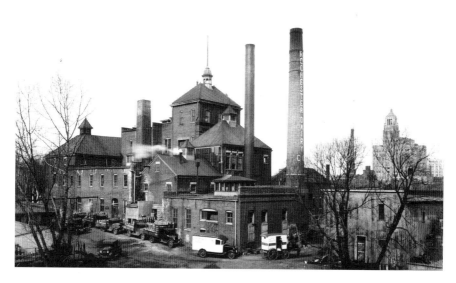

Rochester Dairy Cooperative.

further milk-drying facilities for farmers and local cooperative creameries in southeast Minnesota." Four thousand dairy farmers spanning twenty-three Minnesota, Iowa and Wisconsin counties, joined the cooperative, producing over 200 million pounds of milk a year during the 1940s. By 1957, annual production was over 400 million pounds. The cooperative sold its products nationally under a trade name: Polly Meadows. Its growing production created a need for a new facility, and the company moved out of the old Schuster Brewery buildings in March 1958 to a new facility located on nine acres at 717 Third Avenue Southeast. The old Schuster Brewery was torn down shortly after. By the end of the 1960s, Rochester Dairy Cooperative had merged with several milk-producing cooperatives in the Midwest, forming the Associated Milk Producers Inc. (AMPI), with its headquarters in Wichita, Kansas.

OLMSTED COUNTY POOR FARM

A different kind of farm developed in Minnesota with the passage of an 1864 law. This law, which went into effect on March 4, 1864, required all

counties within the state to provide a farm for the destitute based on the size of its poor population. Twenty-one counties determined their poor population was large enough to require a farm. Most of these counties were located in southeastern Minnesota. Olmsted County purchased 240 acres in Marion Township for $3,600 from Silas Howard in 1868, but in 1874, it bought a new property from T.M. Westfall that was located within Rochester Township. This move was due to poor crop production on the Howard land.

County poor farms were supposed to be good financial investments for the county and the state; however, that wasn't always the case. Ethel McClure writes in her book *More Than a Roof: The Development of Minnesota Poor Farms and Homes for the Aged*, "A self-supporting county farm required land that was suitable for farming, but it was not always easy to determine the fertility of the soil in advance. As a result, there was a considerable selling and trading of farms during the early years."

The first superintendent was John Williams. In 1896, when A.L. Morey was superintendent, the farm moved again, with the county purchasing acreage a mile south of the city. The Olmsted County Poor Farm would remain at this location for the next forty-seven years. This move may have been prompted by public outrage over the farm's rundown and unsafe condition. An opinion article by A.W. Blakely and Sons ran in the June 15, 1894 *Record & Union* and stated that the farm was a disgrace and "better fitted for the detention of criminals than a home for the county poor." It pointed out that the jail was a "spacious and imposing edifice," while the poor farm was a "tumble-down makeshift for a house." The fiery editorial slammed the county for keeping a beautiful and comfortable jail complete with well-kept green lawns and modern conveniences for criminals, while the county's innocent poor, elderly and sick were forced to live in an overcrowded house that lacked even the most basic plumbing. The article ended with a scathing attack, calling on the county to "devote some little care and attention towards supplying the bare necessities of life to those whose only crime is poverty, and in providing a decent refuge to the homeless and aged."

However, despite the move, the living environment didn't improve. The residents occupied an old house, and overcrowding was still an issue. A fire broke out in the spring of 1896, sweeping quickly through the rundown house and destroying it. An April 3, 1896 *Rochester Post* article declared, "Nothing now remains of the house and the [superintendent's cottage] but the foundation and a heap of ashes," and "inmates narrowly escaped burning to death…all their clothing burned…not a vestige of anything saved." Everyone did survive, thanks in large part to the quick thinking of

Morey's son, who discovered the fire and immediately woke everyone up and got them outside to safety. It was determined that a defunct chimney caused the fire. Mrs. Morey had asked the county to repair it, but her request was never fulfilled.

By November 1897, a new house was standing on the old site. A November 26, 1897 *Rochester Post* article heralded it: "A handsome new frame building, a structure that could not fail to at once command the attention and admiration of the most causal observer—the new home of the Olmsted County's poor, presenting, framed as it is in a fine growth of sturdy trees, a picture in its purity of design and harmonious simplicity of coloring, which at once is gratifying to the eye and causes the heart of a true citizen to swell with pride." The *History of Olmsted County 1910* wrote that the county "built a large and commodious building with household conveniences, making it one of the best county houses in the state. The care of the unfortunates has generally been kind and consistent." The house was seventy feet by thirty feet and two and a half stories high.

By the 1920s, the living conditions of poor farms were in question due to a nationwide interest in how the poor, sick and elderly were provided and cared for. McClure wrote that a 1924 national investigation revealed several Minnesota poor farms had "deplorable conditions," which included

Olmsted County Poor Farm.

overcrowding, filthy living conditions and mistreatment. McClure also recorded that in 1927, members of a Minnesota Senate committee "were particularly disturbed by the fate of the so-called decent, law-abiding citizens who in increasing numbers were forced to end their lives among the diseased and the 'morally derelict.'" It wasn't long before poor farms started closing across the state. The Olmsted County Poor Farm closed in 1943.

GROWING UP MEDICAL

Rochester, Minnesota's third-largest city, owes its economic growth to the Mayo Clinic, which is also the largest employer in the Gopher State, employing over thirty-nine thousand. The U.S. government had a deciding influence in developing Mayo's roots here when it sent Dr. William Worrall Mayo to Rochester in 1863 as the examining surgeon for young men enlisting in Minnesota's American Civil War volunteer regiments.

Before coming to Rochester, Mayo supported his growing family by working several jobs in addition to being a practicing physician while living in Le Sueur, Minnesota. He was a newspaper publisher, a farmer and a steamboat operator. Once settled in Rochester, he opened a private practice and found no lack of patients seeking medical care in a rapidly expanding city. From then on, he worked exclusively as a physician, never needing the odd side job again. His sons, William and Charles, eventually joined his practice.

Even though the current Mayo Clinic traces its beginnings to the original medical practice established by Dr. W.W. Mayo, it was a natural disaster that truly cemented its legacy and is often what historians pinpoint as the beginning of Mayo Clinic's unique story and the rise of Rochester as a medical destination for people seeking care from all over the country and, eventually, the world.

SAINT MARYS HOSPITAL

Hot and humid air greeted Rochester residents when they awoke on the summer morning of August 21, 1883, oblivious to the natural disaster that would hit Rochester. Without modern technology, certified meteorologists to interpret the weather data, media systems to deliver warnings and common knowledge about the basic weather conditions predicting a tornado's arrival, the citizens of Rochester were not suspicious and proceeded to go about their day, having no clue what horrible monstrosity was about to descend on them, killing and injuring neighbors and friends and leveling homes and businesses. The atmosphere's elements posed a perfect incubator for the creation of a ferocious storm. Even when dark clouds gathered to the west of the city and the sky turned greenish-yellow, no one took much notice. It wasn't until an ominous silence resounded that residents paused. But by then it was too late. A rumbling freight train scream of an F5 tornado broke the unnerving silence, and few were safe from its mile-wide destructive path.

"Like a great coiling serpent, darting out a thousand tongues of lightning, with a hiss like the seething, roaring Niagara, it wrapped the city in its hideous coils," wrote the editors of the *History of Olmsted County 1883*. "The crashing of buildings and the despairing shrieks of men, women, and children were drowned in its terrible roar." Afterward, "the streets were literally blocked with debris of every kind of trees, house roofs, lumber, great rolls of tin form the roofs of blocks. The public buildings, minus domes, spires, cupolas, and roofs, barns and houses in the streets, were utterly destroyed," wrote *Rochester Post* editors on August 24, 1883. "But worse than all the rest was the news that flew from lip to lip that in North Rochester many lives were lost and many were wounded, while hundreds were without shelter."

The F5 was one of three tornadoes that struck southeastern Minnesota on that long-ago summer day. The other two were F3s; one touched ground near St. Charles in Winona County and the other ten miles south of Rochester in Pleasant Grove Township. Rochester's F5 touched first in Dodge County, four miles northwest of Hayfield. The F5 traveled a total distance of twenty-five miles. The devastating tornado injured over two hundred people and killed nearly forty; however, many of those injuries may have resulted in deaths not recorded as caused by the cyclone.

Dr. Charles Horace Mayo shared memories of the 1883 cyclone during a Kiwanis Club speech on December 30, 1930. He and his brother Dr. William James Mayo were in the north part of Rochester when the storm struck. They heard the twister's roar and witnessed its strength as it destroyed

a bridge, tipped over several railroad cars and blew debris through the air. Mayo recalled how a decorative cornice was torn from the roofline of the Cook House, falling on the brothers' horse. The brothers, along with their horse, found shelter in a small shed, and even though the tin roof blew off, they stayed there until the storm finished its destruction. They didn't expect the chaos that greeted them afterward and were immediately immersed in emergency medical care.

A makeshift hospital was established at Rommel Hall, the city's dance hall. And although the Doctors Mayo worked tirelessly to help the wounded, with assistance from the Sisters of Saint Francis, it was evident to Mother Mary Alfred Moes that Rochester lacked necessary medical facilities. Rural Minnesota didn't have hospitals. Only three hospitals were located outside Minneapolis and St. Paul. Mother Mary Alfred Moes approached the Doctors Mayo about building a hospital in Rochester, a progressive idea at the time and one not positively received at first because a vast amount of the population believed, and not unjustly so, that if you were admitted to a hospital, death quickly followed. Many people refused hospital care. But that idea was about to change. Said Dr. Mayo in his Kiwanis address quoted in the December 31, 1930 *Post-Bulletin*:

> *Mother Alfred and the seven sisters who had started a convent aided greatly in alleviating the suffering of the injured. Mother Allred was a wonderful woman. She was capable and had great vision. She recognized the fact that small places were in need of hospitals as well as larger cities and was instrumental in starting Saint Marys Hospital.*

It was agreed that if the Sisters of Saint Francis built a hospital, the Doctors Mayo would provide medical care. And in 1889, a three-story brick building was completed on the west side of town. The hospital, consisting of thirty-three beds, opened its doors on September 30. On that first day, the Doctors Mayo extracted a cancerous eye in the second-floor operating room, which had a floor painted yellow. Sixty-two patients were admitted to the hospital in 1889. By the end of 1890, that number had climbed to three hundred. Staff physicians were Dr. Christopher Graham, Dr. William Mayo, Dr. William Worrall Mayo, Dr. Charles Mayo and Dr. August W. Stinchfield. Edith Graham, a trained nurse who would later marry Dr. Charles Mayo, taught the Sisters of Saint Francis nursing skills. Sisters Fidelis Cashion, Sienna Otto, Constantine Koupal, Joseph Dempsey, Fabian Burke and Sylvester Halloran composed the nursing

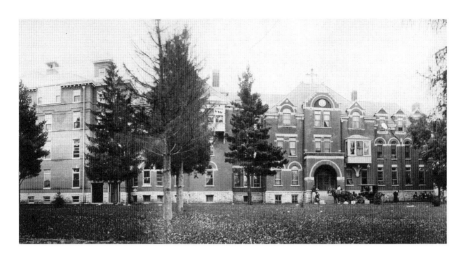

Saint Marys Hospital.

staff. The sisters' day started before 4:00 a.m. and didn't end until after midnight. They fed, bathed, clothed and comforted patients and prayed with and for them. Their role grew to include assisting the physicians with medical treatment and surgical procedures. They also produced much of the hospital's food, managing the hospital farm located on the building's south side, complete with dairy cows and chickens, vegetables and small crops, until 1919, when the hospital purchased two hundred acres of farmland farther west.

Word spread quickly about Rochester's healing hospital, and more patients arrived. Additions were built over the following decades, each expanding bed capacity and increasing operating rooms. The Saint Marys School of Nursing was opened in 1906, and the nurse dormitory and event auditorium were added in 1912. In 1953, the original three-story brick 1889 hospital and its earliest additions were torn down and replaced by the 1956 Domitilla Building. And in 1967, Saint Marys Auditorium and the south and west sections of Marian Hall, the nurses' dormitory, were demolished to build the Alfred Building. Today, the hospital is known as Mayo Clinic Hospital, Saint Marys Campus, and is one of the largest hospitals in the United States with over one thousand beds and fifty-five operating rooms.

MAYO CLINIC'S 1914 BUILDING

On the evening of January 18, 1901, an illustrious crowd gathered to celebrate the opening of the new Masonic Temple. Among the revelers were the Doctors Mayo, Dr. August Stinchfield, Dr. Christopher Graham and their wives. It was an exciting event. Designed by John M. Doherty, the building housed the Weber & Heintz pharmacy and the Doctors Mayo, Stinchfield and Graham on the expansive first floor; it was located at the northwest corner of First Avenue and Second Street Southwest. Rochester's Masonic Temple Association had wanted to construct a new building since 1897, but figuring out how to fund it—not just the construction but the ongoing maintenance—proved challenging until the physicians and druggists offered to lease the first-floor space for a span of ten years. The offer was happily and quickly accepted.

By the end of the agreed decade, the medical practice had grown out of its first-floor space. An addition was built in 1907 to house laboratory space, and another was added in 1909 to provide the flourishing medical practice more offices. During that same year, the Doctors Mayo and Graham

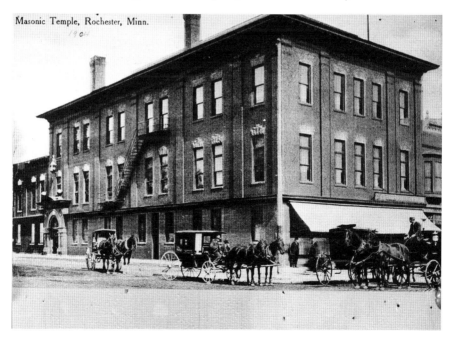

Masonic Temple, Rochester, Minn.
1901

The Doctors Mayo rented the Masonic Temple's first floor for a decade.

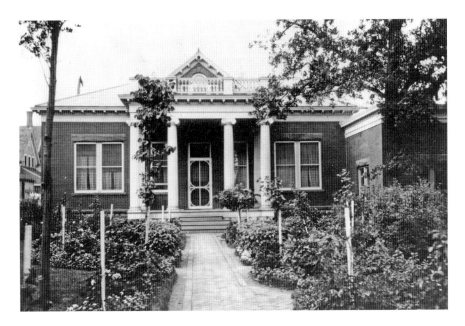

The 1909 Mayo Medical Library.

(Stinchfield retired in 1906) built a medical library at 100 Second Street Southwest. The librarian in charge was Maud Mellish. Mellish, hired in 1907, possessed a background in nursing combined with medical library and editorial work and had proven herself invaluable to the physicians in the two short years since her arrival. The library was razed less than twenty years later, replaced by the 1927 Plummer Building.

By 1912, the physicians' medical practice had grown out of the Masonic Temple's space, and construction began on a new building, the first building that would carry the name "Mayo Clinic." As Mayo Clinic expanded, the building would be known as Mayo Clinic's 1914 or "Red Brick" Building, and its location was the site of Dr. William Worrall and Louise Mayo's home, where Dr. Charles Horace Mayo was born. Designed by architect Franklin Ellerbe and Dr. Henry Plummer, the building was an impressive structure and signaled the start of an integrated medical practice complex that would span several downtown Rochester blocks and eventually spread to locations across the country. However, its headquarters and biggest campus, often affectionately called "Mother Mayo" by employees, remain in Rochester. When it opened on March 6, 1914, hundreds of spectators walked through its doors, curious to see one of the most modern medical facilities in the country. And although many Rochester residents called the

building "Plummer's Folly," the media were more enthused. The *Rochester Post & Record* called the building a "culmination of the highest ideals for the purpose of which it was created—the relief of the physical ailments of the human race and scientific research in the field of medicine and surgery."

The four-and-a half-story building was made of dark red Pennsylvania brick with creamy Missouri stone trim. It held various laboratories, X-ray rooms, research and clinical departments, a pharmacy, several offices, examination rooms and a large library and editorial department. "The south wing of the third floor is given cozy and comfortable quarters for the staff to study and read, adjoining which is a large room equipped with immense steel racks for the accommodation of the large medical library," described the *Post & Record*. "On the opposite side of the library is a spacious and magnificently appointed assembly room where the mid-week conferences of the staff will be held....Conspicuous in the assembly room, on each side of the massive fire place, hangs the beautiful oil paintings of Drs. William J. and Charles H., while on the mantle [*sic*] stands a bust of the late Dr. W.W. Mayo."

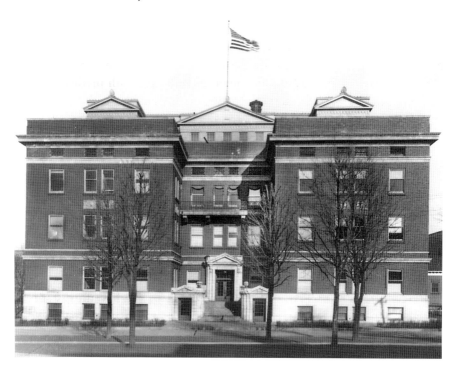

Mayo Clinic's 1914 Building.

A spacious lobby greeted patients on the first floor. Several skylights allowed sunlight to flood the room, and large potted palms and various other plants were placed throughout the space. There were three hundred wicker chairs with comfortable cushions, and Rookwood tile decorated the square columns, the floor and the eye-catching staircase at the building's center. The Rookwood Pottery Company of Cincinnati, Ohio, designed and manufactured the lobby's decorative tile, which also adorned the central fountain and a smaller drinking fountain. The Imperial stairway's first-flight landing offered a prominent lobby view before dividing to the left and right, ascending to the second floor.

Many state-of-the-art systems were installed within the 1914 Building, thanks to the collaboration between Frederick Maass & McAndrew and Dr. Henry Plummer. A colored light system kept track of the doctors by assigning each one a color. Staff could find a doctor easily by looking at the color code displayed outside patient examination rooms. Other innovative inventions included a medical equipment steam sterilization room; sinks with knee levers that allowed doctors and staff to turn faucets on and off without touching them; a pneumatic tube delivery system for medical records, mail and other correspondence; and a ventilation system that pushed fresh air through the building at three-minute intervals.

When the Plummer Building was completed next door, the 1914 Building's front entrance was closed permanently and Mayo Clinic's main entrance moved to the Plummer. Patients entered through the structure's impressive bronze doors to gain access to the clinic's first building, which was now connected to the Plummer. The 1914 Building would be an integral part of Mayo Clinic until 1973, when it was closed to the public and used for storage. It was demolished in 1986 and replaced with the fourteen-story Siebens Building. However, before its destruction, several artifacts were removed for preservation. These objects included the 1912 cornerstone, the staircase railing and many other decorative elements. The drinking fountain was also saved and eventually displayed in the Subway of the Siebens Building, where it remains today. Many people walk past the fountain without realizing its historic significance, but its tiled backsplash in shades of green surrounded by larger beige tiles and a half-moon-shaped bowl trimmed with flowered medallion motifs extending slightly away from the wall is beautifully designed and offers a glimpse of the 1914 Building lobby's décor.

ROCHESTER METHODIST HOSPITALS: COLONIAL AND WORRALL

When Colonial Hospital opened in 1915, it included 140 beds, two operating rooms and two five-story sections. Initially called the Colonial Hotel, a combination hotel and hospital, the name changed when a third wing was added in 1916 and a majority of the space was used for medical purposes. The E-shaped hospital faced First Avenue Northwest.

The hospital grew over the years, adding a sixth floor to each wing and a fourth wing on the north side of the medical campus in 1950. The seven-story addition included four operating rooms, a post-surgery recovery area, laboratories, classrooms, offices and living quarters for physicians. The fourth wing increased the hospital's patient capacity to 380 beds. The original two wings and the 1917 third wing were remodeled, allowing for more patient rooms, another operating room, larger nurses' stations and expansion of the emergency room.

In 1918, the hospital admitted its first students into its newly formed Colonial Hospital Training School of Nurses. The yearlong program was created in response to a nursing shortage in Rochester. The lack of nurses was attributed to two things: 1) the explosive growth of the people arriving in Rochester seeking medical treatment and 2) loss of trained nurses enlisting for military service in Europe during the First World War. By 1920, the program had expanded into a three-year program. Its name changed to the Kahler Hospital School of Nursing in 1921 and the Methodist-Kahler School of Nursing in 1954. The school closed in 1970, having graduated 3,827 nurses over its nearly five decades of operation.

Four years after the Colonial was built, another hospital was raised in Rochester. The five-story Worrall Hospital was located a few blocks south of Colonial at 215 Third Street Southwest and opened on January 1, 1919, to great aplomb. Rochester's Child Welfare League hosted an open house event between 3:00 p.m. and 9:00 p.m. that included public tours of the building for an admission fee of twenty-five dollars and snacks and tea served by Phoebe, Edith and Charles Mayo.

An article ran the following day in the *Rochester Daily Bulletin* and declared:

> *The building is one of the most completely equipped of its kinds in the country, and the detailed and careful planning of each feature of the structure was a wonder to those who went thru yesterday....From the fifth floor to the basement, nothing has been forgotten for the comfort of patients*

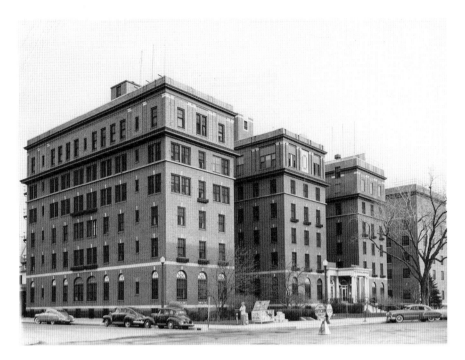

Colonial Hospital opened in 1915.

and doctors. The reception room is beautifully furnished. Floors throughout the building are finished in terraza and the walls in a blending cream color. The hospital contains 126 beds and each room is fully furnished with a mahogany dresser and specially equipped hospital bed.

Glass knobs decorated hospital doors, each floor had an operating room and a canopied outdoor roof garden topped the fifth floor.

Frederick Maynard Mann designed the building. Maynard founded the University of Minnesota School of Architecture in 1913 and was the architect for the university's Memorial Stadium, which was built in 1924.

Eventually, Worrall Hospital acquired an adjacent building, naming it Worrall Annex. The addition added more beds and operating rooms to the hospital and housed several medical specialties.

The Kahler Corporation owned both the Colonial and Worrall, but by 1950, the company had turned its focus from the hospital business to the hotel business, selling both properties in 1954. The two hospitals were incorporated into Rochester Methodist Hospital. A subway system connected the buildings.

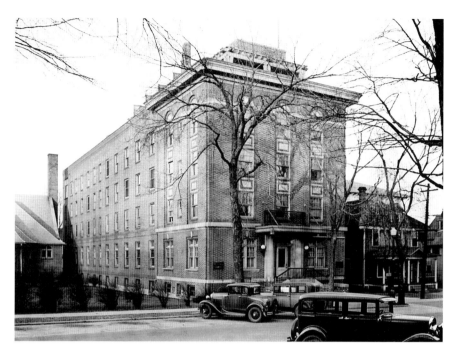

Worrall Hospital opened in 1919; the Worrall Annex was added later.

A new 794-bed Rochester Methodist Hospital was built in 1963 on the west side of the Colonial. Worrall Hospital was sold, becoming part of the Mayo Clinic campus, and it saw its last patients in 1966. Worrall Annex was razed in 1967 and the remaining hospital building in 1970. The Guggenheim and Hilton Buildings are located where the Worrall once stood. Most of Colonial Hospital was demolished in 1985 to make room for a large addition to the 1963 hospital building, but the north wing remains, now part of the Mayo Clinic, Methodist Campus.

ROCHESTER STATE HOSPITAL

The Minnesota state legislature passed a law in 1873 approving funding for a second state hospital since the first, in St. Peter, was dangerously overcrowded. The hospitals were originally built to house those suffering from alcoholism, so an amendment to the law in 1874 created a ten-dollar tax on liquor distributors to help with funding. Eventually, inebriate care

reverted to the counties, and the state focused on providing care for the mentally ill. Rochester's campus name changed to the Second Minnesota Hospital for the Insane in 1878 before gaining its permanent name in 1883.

In April 1876, state commissioners selected 160 acres owned by Jacob Rickert on Rochester's east side as the location for the hospital. "It is among the best land in the county," declared Rochester's *Record & Union* in its April 21, 1876 edition, "and Silver Creek runs through it. There is a nice elevation in the center, evidently put there for a building site." The purchase price was $9,000. By autumn, Minneapolis architect L.S. Buffington was chosen as designer and A. D. Rockey, also of Minneapolis, selected as contractor. The building design followed the Kirkbride Plan, an architecture style for similar hospitals across the country. Developed by Dr. Thomas Story Kirkbride, a prominent psychiatrist, this style consisted of administrative offices in the center, which often included superintendent housing and an impressive tower, and patient care wings jutting outward on either side. The design allowed in large amounts of natural light and provided excellent ventilation. The hospitals built in this style were usually three to five stories in height and sat amid immaculately manicured grounds, looking out over several acres of farmland.

Construction commenced in the spring of 1877, and the plans included six structures. "In size, the building will be 375 x 155 feet, with a basement of stone, the main building being three stories high, and the other five buildings being two stories high each," reported the *Rochester Post* on September 23, 1876. "The material will be the very best brick with stone trimmings, and a tower eighty feet in height will add to the architectural beauty. Steam heating apparatus will be used and most thorough ventilation provided for." One of the six structures was an amusement hall, located at the rear of the administration building. It contained the library, game and card rooms, a billiard room, a lecture hall, a gym and a barbershop. Hallways that were 25 feet long and 10 feet wide connected the hospital wards to the administration building. There were two patient wards for residents who depended on the state to fund their care and two additional wards designated for patients paying out of pocket. The *Record & Union* enthusiastically reported on its aesthetic design, declaring, "The stories are of good height, the tower to the main building gives it dignity and prominence, and the towers on the paying patients and amusement buildings give grace, sky line and beauty

Rochester State Hospital Administration Building.

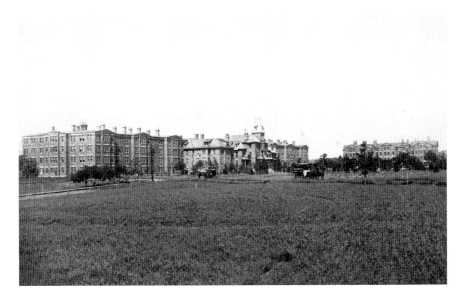

The Rochester State Hospital.

of combination which a building of this magnitude requires. Porches, verandas, bay windows, balconies, etc., give it a home like appearance, taking off the stiff look it otherwise would have."

The hospital opened on January 1, 1879, its first one hundred patients transferred from St. Peter State Hospital. Another wing was added in 1880 to accommodate female patients. More additions were funded in 1882, 1883 and 1884, increasing the hospital's capacity to six hundred. Eventually, the hospital would expand to house more than one thousand patients. The Rochester State Hospital School of Nursing started in 1889, graduating its first class in 1892, and operated until 1943. A rock quarry opened in 1920, supplying lime fertilizer to local farmers and stone to the construction of the Kahler Hotel, Mayo Clinic's Plummer Building and several Saint Marys Hospital additions. The quarry closed in 1950. Patients worked at the quarry and it supplied the hospital income, helping pay for expenses. Another cost saver for the hospital was its farm, which covered five hundred acres of the eventual one-thousand-acre campus. The farm included livestock and crops, which were slaughtered and harvested onsite to feed patients. The farm closed in 1967, and the state leased the land. A single limestone silo remains. Built in the 1930s, it was used to store feed for the farm's dairy cows and stands not far from Rochester Community and Technical College.

Although generally considered a stellar medical complex, the hospital had its problems. One of the first was reported on April 1, 1889, when a hospital resident died in what was initially ruled an accident. Thomas Combs, a thirty-eight-year-old African American, was assigned a painting job and fell from scaffolding and died shortly after; the Olmsted County medical examiner ruled internal bleeding sustained by the fall as the cause. A patient came forward and shared that two staff members, August Beckman and Edward Peterson, had beaten Combs with a cane. Dr. Jacob Bowers, the hospital's first superintendent, dismissed both men and didn't report the incident to authorities, but news slipped out and an investigation commenced, leading to a report stating the hospital lacked qualified staff with adequate supervision, creating an environment susceptible to abuse. Bowers resigned, and Dr. Arthur Kilbourne was hired, immediately instigating several improvements. The courts convicted Beckman and Peterson of manslaughter, and they were sent to prison. Another suspicious death happened three years later when patient George Halm was found dead. His death was ruled an accident. The hospital's image was tarnished for a time, but its reputation eventually recovered.

Reported the *Olmsted County Democrat* on October 5, 1900:

> *A visit to a great institution of this kind for the first time affords a great surprise to a majority of people. They had no idea that the grounds were a park, dotted with foliage and flowering plants, on an extensive stretch of green lawn. They didn't suppose the corridors were carpeted and the walls hung with pictures. They little realized what the nurses and doctors were doing daily for the health and comfort of patients. The enormous bake shop and congregate dining room were a revelation. That the minds and bodies of patients were given every possible advantage to the end of restoration to normal conditions, was never considered. The large scale on which everything is conducted and that the institution is not an "asylum" but a "hospital" are the permanent impressions that visitors carry away with them.*

Located in the heart of the grounds was the hospital's cemetery, a two-acre burial place tucked away in a large peaceful glen surrounded by woods. It was actually the hospital's second cemetery. Rosemont Cemetery is recorded as the first cemetery, but its location remains unknown. The last burial at the State Hospital Cemetery was in 1965. It is home to 2,019 graves. The first

grave markers were made of cement, created by pouring the concrete into tin food cans. Only a number identified the occupant—no name, no birth date, no death date. As time marched across its surface, the cemetery and its occupants were nearly forgotten.

The cemetery became part of the Quarry Hill Park and Nature Center, and its markers disappeared. For a time, its gentle knoll was used as a sledding hill. Eventually, a nonprofit group formed with a mission to preserve and protect the cemetery. This included conducting research to discover those buried there. A $100,000 state grant helped to cover expenses. Hundreds of flat gravestones, complete with names and dates, were purchased and installed, and on October 5, 2008, a dedication ceremony was held. The engraved names and dates provide an introduction to rediscovering each patient's individual history, such as in the case of William H. Costley, the son of the first slave freed by Abraham Lincoln. Costley's mother, Nance Legins-Costley, was an indentured servant who fought for her freedom, with Abraham Lincoln's help. Lincoln, just five years into his law career, took her case to the Illinois Supreme Court, a successful venture that secured Nance her freedom and that of her young son. So how did Costley end up in the Rochester State Hospital Cemetery? While enlisted in the Twenty-Ninth Regiment of U.S. Colored Troops for Illinois during the Civil War, he sustained a severe head wound. The effects of this injury eventually led to his admittance to Rochester State Hospital.

After 103 years, the State of Minnesota closed the hospital at 2110 East Center Street on January 1, 1982. The closure was a cost-saving measure, supposedly cutting $7 million from the state's budget. The closure caused 519 people to lose employment and the relocation of 350 patients. The buildings were sold to the Federal Bureau of Prisons for use as a Federal Medical Center. The original buildings and several of its later additions were demolished.

COMBINING MEDICAL CARE
AND HOSPITALITY

With the creation and establishment of Mayo Clinic and its subsequent cultivation into one of the leading medical practices in the country and eventually the world, the mass of patients arriving in Rochester seeking healing care swelled into an overwhelming wave of visitors needing places to stay. Hospitality became a top priority and created another profitable business opportunity. Most of the earliest hotels included hospital services of some kind.

COOK HOTEL

One of the most distinguished hotels was the Cook Hotel, also called Cook House, located on a large lot at the corner of Broadway and Second Street Southeast. Built in 1869 and designed by St. Paul architect A.M. Radcliff, it covered a 110-foot-square block and was five stories, including the basement. The basement had a wine cellar, vegetable cellar and large storage area. Four stores occupied the first floor, along with a billiard room, barbershop and laundry. The First National Bank was also located on the first level. On the second floor were the hotel lobby, a reception room and dining room, offices, a baggage room, parlors for gentlemen and ladies and a few bedrooms. Most hotel bedrooms were located on the third and fourth floors. According to a May 1, 1869 *Rochester Post* article, the main entrance on Second Street

Southeast was "surmounted by a beautiful cut stone portico, above which there will be a balcony at each succeeding story." Brick was used for the exterior, along with decorative cut stonework ordered from a quarry in nearby Mantorville. Deep within the building was a large horizontal support beam. When it was put in place on July 10, 1869, the *Rochester Post* ran a story describing it: "A wrought iron girder is to be placed on the top of the first story wall, fifty feet from the east front of the building upon which is to rest a brick wall rising fifty feet high and sixteen inches thick. This beam is twenty-two feet in length, and weighs 3,600 pounds."

John R. Cook's hotel, which many in Rochester believed would be a failure due to its commodious size, cost $80,000. It wasn't long before people snickered about Cook's "white elephant" and waited to see it fail. But despite the negative public predictions, the *Rochester Post* gave it glowing reviews in its May 1, 1869 article, claiming:

> *With this magnificent structure, completed according to the plans and specifications, Rochester can justly claim the most splendid and superb hotel in the State. The size; the elaborate, costly and high ornamental construction and finish of the walls; the convenience and method of the internal arrangement, all combine to make it not only an ornament to our city but a lasting and substantial honor to the proprietors, Mr. John R. Cook and Mr. O.P. Whitcomb.*

The cornerstone was laid on July 10, 1869. The Silver Cornet Band led a large crowd to the building site for the ceremony. Several local newspaper issues, U.S. currency, a drawing of the city and the names of those involved in its creation, including the owners, builder and architect, were placed inside the cornerstone.

Still unfinished on opening night was the hotel's forty-nine-foot by forty-six-foot dining room with a fourteen-foot-high ceiling. Designed by A. Rank of St. Paul, the room's décor consisted of heavy wood beams and iron posts. The center beam crossed the room lengthwise, the iron posts giving it support. The columns were painted to resemble Italian marble, and white decorative capitals graced their tops. The ceiling consisted of wood panels, each painted a pale green tint with an intricate scrollwork and flower design in its center, giving the room an outdoor garden atmosphere. Wall panels between the room's windows were painted in light shades of pink, and upon entering the room, guests were greeted with paintings of vases overflowing with bright flowers and colorful fruit. *Rochester Post* editors

raved about the room's design in an October 29, 1870 article, saying, "It is impossible for us, in any description, to detail the artistic and sensuous effect of shade and tint....It is as perfect in point of taste and finish as we can imagine."

Times were challenging for the Cook Hotel in its first few years. Shortly after opening, a financial crisis hit Europe and America. The Panic of 1873, combined with a grasshopper infestation that destroyed thousands of crop acres throughout Minnesota, affected Rochester's economy, slowing it considerably for the next five years. Wheat, southeastern Minnesota's most abundant crop, was a victim of the insect plague. The Cook Hotel also experienced financial difficulty during the 1890s' economic depression but never closed its doors, developing into Rochester's most prestigious hotel. An upswing in the economy helped it survive, but its rise to the crown jewel of hotels was due to the brilliant leadership of hotel manager John H. Kahler. Kahler took over in 1893. He expanded the hotel to one hundred spacious rooms by creating an addition. Every hotel room was newly decorated and refurnished. Due to

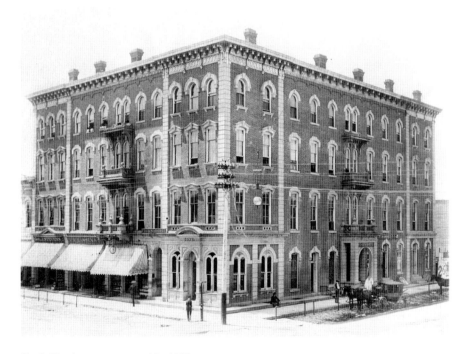

Cook Hotel was constructed in 1869.

First National Bank.

overcrowding at Saint Marys Hospital, Kahler worked with the Doctors Mayo to equip rooms for hospital use. Electric lights replaced gas, and paved sidewalks were added alongside the building.

A September 28, 1900 *Post & Record* article praised Kahler for his "keen business qualities, magnetic influences, and the popular manner in which he conducted the hostelry." He increased the income of the hotel substantially in his first two years. In 1898, the hotel's total income was $17,309, and by the first half of 1900, income had already surpassed that amount with $17,850. Kahler vastly improved the hotel's finances and its reputation. The *Post & Record* declared proudly, "The far-famed Cook's Hotel of this city is one of the best institutions of its kind in southern Minnesota. It is a haven for all high class visitors that make calls to our city and does a flourishing business with the business and professional men of Rochester as well as those from all parts of the country from New York City to the Pacific."

The hotel experienced four fires during its tenure as a premier downtown hotel: 1879, 1881, 1882 and 1947. The February 3, 1947 morning fire was the death knell for the Rochester landmark. Luckily, all 104 guests vacated safely with the help of firemen, but the upper two floors were removed after the fire and the hotel closed. The building was demolished in 1949.

HOTEL ZUMBRO

The Hotel Zumbro, sometimes referred to as the Zumbro Hotel, opened on March 19, 1912, at 101 First Avenue Southwest. Owned by John H. Kahler, it partly owed its creation to the Cook Hotel. The Cook Hotel wished to renovate one floor for surgical purposes, eliminating some boarding rooms. There was a need for another hotel to accommodate visitor overflow. Never to let a financial opportunity pass, Kahler purchased property in a prized downtown location for a new hotel. Jack El-Hal writes in *Lost Minnesota: Stories of Vanished Places*, "Sitting on a prominent block in Rochester's central business district, the hotel was the first component of a lodging empire that Kahler would eventually develop in order to capitalize on the growing number of Mayo patients and their families seeking overnight accommodations." Construction began on the five-story Hotel Zumbro in 1911. The $150,000 hotel contained forty-eight guest rooms when it opened. Each floor boasted a different color palette. In addition, like the Cook Hotel, the brick building included an operating room and hospital rooms on one floor; its hospital function discontinued in 1915. In 1917, Kahler purchased the old West Hotel on the neighboring lot and tore it down to build an eight-story addition, adding seventy-seven guest rooms, offices and medical laboratories. A unique feature of the new addition was a walkway bridge connecting the hotel to Mayo Clinic's 1914 Building—Rochester's first skyway. In 1927, Kahler had the ingenious idea to build an underground pedestrian tunnel from the hotel to Mayo Clinic's Plummer Building. Guests walked through the tunnel to medical appointments, staying warm and protected from harsh Minnesota winters.

The hotel's opening, held on March 19, 1912, included an afternoon reception highlighted by a musical performance, games of cards in the dining room, dancing in the lobby and an orchestra greeting guests as they arrived. The *Olmsted County Democrat* declared:

> *The opening became a society function and the best party gowns were not too good to honor the occasion. The magnificence of the structure and the richness of the furnishings were indeed worthy of the best apparel and the tiled floors and velvet carpets felt the swish of much silk and fine lace.… From the marble-tiled floor of the lobby to the mahogany furnished rooms above, no detail that could contribute to the air of luxury, the suggestion of convenience or the thought of practicality was omitted from this structure, and guests will feel that Rochester gives them a cordial welcome.*

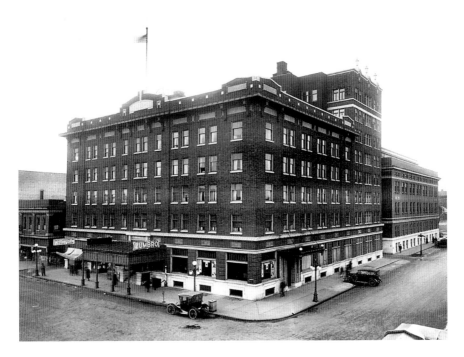

Hotel Zumbro was built in 1912.

The paper described the guest rooms as having "commodious closets," and "carpeted in heavy Wilton of exquisite design" with dark wood baseboards and crown molding. "Cypress wood finishings being treated to give a rich color, relieved with gold embellishments," decorated the lobby, and the café was "ornamented in white and gold." The hotel's dining room served up scrumptious meals, especially on holidays. Among its list of menu items for Christmas 1915: oyster cocktail, candied sweet potatoes, roast turkey with dressing and cranberry sauce and an old-fashioned English plum pudding, drenched in brandy and flamed, with white hard sauce.

Providing delicious food in a pleasing dining environment was important to the hotel, and during the 1950s, it opened Scandia, a restaurant with Scandinavian décor. The March 18, 1858 *Post-Bulletin* described the forty-two-foot by eighty-six-foot dining area as "sleek, modern, yet warm and hospitable," with cherry wood paneling and white ceilings, and "counter and table tops are a smooth white Formica, leather upholstery is lemon yellow, sand floor tiling is turquoise flecked with white." Scandia was a combination cafeteria and buffet. A large mural decorated one wall, depicting a "Swedish

wedding celebration combining all the colors of the room. On the wall behind the counter are glazed tiles made in England especially for Scandia, some featuring crown motifs, others with small paintings bearing typical Scandinavian sayings." Food was served on yellow and white China; the light fixtures were brass and the curtains turquoise. Robert Lederer of Chicago's Mandel Brothers designed the restaurant.

During the 1930s, '40s and '50s, the hotel hosted many famous people, including state and national politicians, Olympic athletes and Hollywood royalty. In 1987, the Kahler Corporation razed the historic hotel. At the time of its demise, it was known as the Kahler Zumbro Hotel and had 165 guest rooms. A $20.5 million Kahler hotel complex replaced the historic structure, which had just a few years before been added to the National Register of Historic Places. The hotel hosted its last event, the Wrecker's Ball, shortly before demolition, and longtime employees and visitors lamented its loss.

CHUTE SANITARIUM

Charles H. Chute arrived in Rochester in 1865 when he was six years old. After graduating from the public schools, he worked for four years for the Rochester Street Department before leaving for South Dakota, where he resided for twelve years before returning to Rochester with his wife, Margaret Hosch, and his ten-year-old daughter. The Chute family settled in a house at 123 Third Street Northwest. Charles was employed as a baggage handler at the Chicago & North Western, and Margaret opened their home to boarders to help earn income. It wasn't long before Charles quit his job to help his wife run a booming hostelry. Many of those who stayed at the Chutes' home were patients of the Doctors Mayo. Rochester's transient population was growing every year, and it was common for people to be turned away from the city's hotels because a room was not available.

Due to a rising demand to serve these visitors, Charles and Margaret decided to expand the function of their boardinghouse by opening a sanitarium, complete with hospital wards and an operating room. They bought the lot next to their house and erected a two-and-a-half-story structure that measured thirty-two by sixty-nine feet. The August 17, 1906 *Post & Record* reported that it would be a "large, handsome structure" with thirty-five rooms: "many of these are arranged en suite and are fitted out with every modern convenience. The plumbing and lighting are of the

highest class and the entire building designed for a thoroughly modern sanitarium." The article was especially praising of Margaret, stating, "Mrs. Chute has been in the boarding business for many years and her success has quantified her to take charge of an undertaking of this nature. She enjoys the respect of all, and when the proposed sanitarium is started then there is little doubt of its success." This prediction proved true.

Just six months after opening, the Chutes announced plans to build an addition in order to accommodate the number of patients who needed observation and care before and after surgery. The *Post & Record* of March 22, 1907, reported, "The place has become so popular with patients that the management has found it necessary to nearly double the present capacity. A fine new operating room will also be installed in the new addition and when the entire building is completed it will be one of the best equipped and largest in the city."

The contract for the annex was awarded to Taylor & Schellin for a cost of $10,000. The new sleeping rooms had closets and bathrooms. There were three wards, which were described by the *Olmsted County Democrat* as "bright, cheerful rooms arranged especially for the use of patients not able to take private rooms" in a November 8, 1907 article announcing the opening. Due to the constant threat of fire, ten fire escapes were secured to the building to offer plenty of options for boarders needing to exit in the case the event

The Chute Sanitarium.

occurred. A dining room and kitchen were on the first floor. The paper commended Margaret for her part in creating such a fine facility: "Mrs. Chute, who has co-operated with her husband in all the plans for increasing the size of their hotel, has seen to it that every convenience that could minister to the comfort and welfare of her patrons has been provided."

The Chutes ran the Chute Sanitarium until 1911, when they sold it to longtime Rochester resident Mark L. Towner. The Chutes moved from Rochester to the state of Washington. Towner continued to own and manage it until 1917. After Towner's ownership, the building operated as a hotel and an apartment complex. A fire destroyed the building in 1981.

KAHLER AND DAMON HOTEL

Most Rochester residents and visitors are familiar with the Kahler Grand Hotel located at 20 Second Avenue Southwest in the middle of downtown, surrounded on three sides by Mayo Clinic buildings. Built by John H. Kahler in 1921, the eleven-story building was originally designed as a combination hotel and hospital, which included surgical suites and laboratories. It no longer operates as a hospital, but as Rochester's oldest surviving hotel, it boasts the strongest tie to Mayo Clinic and takes pride in that historical relationship by catering to patients from around the globe. But there was another Kahler, the first Kahler, and its origins began with one of the city's most elegant homes.

The house was located on the site where Mayo Clinic's Gonda Building now stands. Prominent Rochester merchant Elliott Ainsworth Knowlton and his wife, Ella Rebecca Blake, purchased the property in 1889. J.D. Blake was the original owner of the house, having built it sometime between 1873 and 1875. Blake was Knowlton's brother-in-law and business partner.

The three-story brick building consisted of a turret resembling a witch's hat atop a rounded corner tower, a front porch ornamented with decorative white brackets and turned posts, gable roof dormers, long and narrow double-hung windows, a horizontal cornice above large continuous corbels framing the roof line, a shingle-covered gable roof with a widow's walk defined by elaborate ironwork and tall brick chimneys.

When the *Olmsted County Democrat* announced the Knowlton House had been sold and would be converted into a sanitarium in its July 27, 1906 edition, it called the residence a "palatial home," a "splendid mansion," a

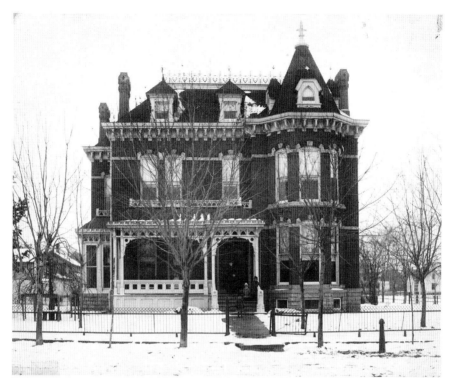

The first Kahler Hotel originated in merchant E.A. Knowlton's Victorian home.

"stately brick structure beautifully located…and surrounded by one of the best kept lawns in the city." A *Post & Record* article on the same day lamented, "It will be difficult for the people here to reconcile themselves to the project of the Knowlton home becoming a sanitarium for there is something almost incongruous in the thought of the beautiful residence being made into a sanitarium," and it is "recognized as one of Rochester's finest residences and the lawn has been pointed to as the prettiest in the city." But despite the general discord of the Knowltons' neighbors at the prospect of the elegant structure's future, the Knowlton family pocketed $25,000 from the Rochester Sanitarium Company and moved out of the home they'd resided in for seventeen years.

When it opened in May 1907, after being renovated to the tune of $40,000, it consisted of ninety-five rooms. The *Rochester Daily Bulletin*'s May 4, 1907 article claimed, "The hotel is artistically decorated, beautifully furnished, and equipped with every modern convenience." The paper also described the interior:

The rooms are large and airy and furnished in oak and mahogany. Brass bedsteads are used to equip a majority of the rooms. The beauty of the house lies in the charm of its bedrooms. The decorator, by his clever use of paint and brush, has effected harmonious combinations and the furniture and oriented rugs blend richly with the color scheme. No two rooms in the house are decorated the same way.

The Kahler Hotel's general manager was John H. Kahler. The physician in charge was Dr. John E. Crewe. The hotel catered to patients of the upper class who desired private, personal, one-on-one medical care from nurses and physicians. It did not house those with chronic or infectious illnesses, its focus instead on those individuals who had surgery at Saint Marys Hospital and were advised to not travel for several days or weeks, staying close to physicians and nurses for observation and treatment. Dr. William and Dr. Charles Mayo performed medical procedures in Room 316. Visitors enjoyed spending time in the commodious and airy first-floor lobby-lounge. The pleasant room possessed wood flooring highlighted with rich oriental

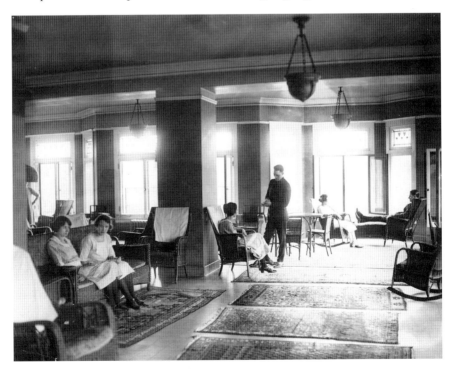

The Kahler (Damon) Hotel included a sunny lounge area with forty-six windows.

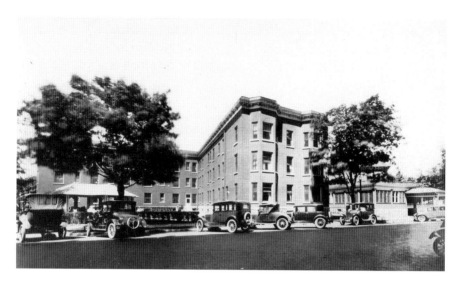

The Kahler Hotel was renamed the Damon Hotel in 1921.

rugs, high ceilings edged with crown molding, dark mahogany woodwork (eventually painted) and comfortable wicker furniture and fashionable chandeliers. But its most distinctive feature was its wall of forty-six windows, which allowed an abundance of rejuvenating natural light. Between 1910 and 1913, patient demand dictated adding a wing on either side of the building, expanding the hotel's capacity significantly and drastically changing the look of the beautiful mansion forever.

The Kahler was more than a place for elite Mayo patients to recuperate from surgery. The hotel also served as an important event venue for Rochester residents. A November 10, 1960 article in the *Post-Bulletin* stated, the hotel "was the center of the city's social activities and the scene of many fashionable parties." Guests included Wisconsin politician Robert M. La Follette, professional baseball player and evangelist Billy Sunday and Charles William Post, owner of Postum Cereal Company, which created the cereal Grape-Nuts in 1897. It also housed a barbershop, a card and gift shop and the Rochester Book Bindery, which was established in 1936 by Ernest H. Vielhaber and eventually owned by his sons, Gerald and Ernest J.

With the opening of the new Kahler Hotel in 1921, the first Kahler Hotel became the Damon Hotel, named for Hattie Damon, Dr. William Mayo's wife. In 1926, the Damon ended its hospital function, including closing its expansive cafeteria for Mayo Clinic employees. The Methodist-

Kahler School of Nursing moved its offices and classrooms to the Damon in 1926 and converted the north wing of the building into a dormitory for 130 students. The school remained at the Damon Hotel until shortly before it closed in 1960.

DR. CHARLES AND EDITH MAYO HOUSE

Another fanciful house converted into a hospitality establishment was the first home of Dr. Charles and Edith Graham Mayo at 419 Fourth Street Southwest. Nicknamed "Red House," the three-story 1893 Queen Anne Victorian was built next door to Dr. William and Hattie Mayo's 1888 Queen Anne, which Mearl W. Raygor describes in *The Rochester Story* as "an elegant spacious house with three large fireplaces and a covered driveway. The house was lighted with gas lights and had a speaking tube from the house to the barn." Whereas Dr. William and Hattie selected an undistinguished pale yellow for the exterior color, Dr. Charles and Edith chose a splashy brick red. The brothers shared the carriage house at the rear of the property and communicated through an underground speaking tube between the two

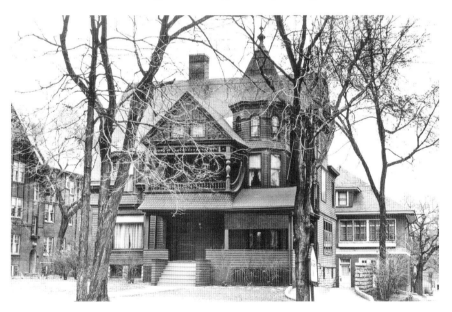

The Edith Mae Guest House.

homes, added after their wives opposed construction of a central library and study to connect the two homes.

In 1910, Charlie and Edith built a country home called Mayowood on the west side of Rochester. They gifted their beloved "Red House" to the Young Women's Christian Association (YWCA) in 1919. A January 20, 1919 *Rochester Daily Bulletin* article announced the donation and reported, "The site consists of two fifty-foot lots upon which stands the spacious mansion of twelve large rooms; at the rear are two garages, both of which are supplied with housekeeping apartments," and that "real estate men declare it to be one of the best pieces of property in the city and a gift representing many thousands of dollars." One of the roles it played while part of the YWCA was to offer accommodations to single women visiting Rochester. The "Red House" would be home to the YWCA until 1944. During the second half of the 1940s and into the 1950s, it was used for single female nurses and called Edith Mayo Hall. In its last years of existence, it was known as the Edith Mae Guest House, another boarding choice for Mayo Clinic patients.

In 1980, the home was awarded a place in the National Register of Historic Places. Sadly, this designation did not save it from destruction. It met the fatal blows of the wrecking ball on March 7, 1987. Mayo Clinic now owns the property, and its Opus Building, housing imaging science research, sits at that location.

PIERCE HOUSE AND ROCHESTER HOTEL

When a fire devoured the Stevens House located at 217 First Avenue Southwest in March 1877, Rochester residents wondered about the fate of the downtown lot. They didn't have long to wait. Owners Joseph and Sarah Pierce, who purchased Stevens House in 1874, announced they would rebuild immediately and the new hotel would be called Pierce House.

The Pierce House opened for business in August 1877. The *Record & Union* declared it "one of the finest buildings in the city" in an August 3 article. It also provided some description, stating that the first floor possessed "a wide hall, to the right of which is the office, a large pleasant room, which has a fine counter, beautifully ornamented and a washstand with marble bowls" and "left of the hall is the parlor, which is elegantly furnished and ornamented with a large mirror and many fine pictures." The second floor consisted of parlors and bedrooms "furnished with

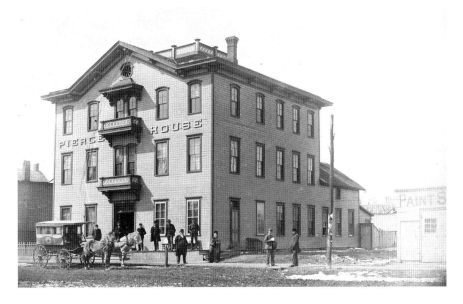

Pierce House opened in August 1877.

the best upholstered furniture, Brussels carpet, fine chandeliers, and the windows are hung with lace curtains, descending from gilt and walnut cornices." A bridal chamber and several more bedrooms were located on the third floor, and the fourth floor, resembling a small loft, had an open room that could be used to house visitor overflow if necessary. The hotel had a total of twenty-six rooms when it opened. The hotel's name was printed boldly across the building's façade, emblazoned in raised gold letters, and on the roof "a large cupola surmounts the building from which a splendid view of the city and surrounding country can be obtained." Furnishings included $400 worth of silverware and two chandeliers from local jewelry store Smith Brothers, several curtains purchased from Rochester merchant W.W. Ireland and parlor sets costing $150 each. The total cost for building the hotel, including furnishings, was $13,000. The *Rochester Post* wrote on August 3, "The house is well ventilated and lighted. There are transoms over every inside door, and every room in the building has from one to three windows.…In point of economy of room, as well as in convenience and pleasantness, the plans and arrangements could hardly be excelled. Every square foot seems to be appropriated to the best advantage, while there is not a single unpleasant, unsightly or inconvenient room in the house."

When the Pierce family moved to Jamestown, South Dakota, in 1880, they sold their reputable hotel to James Fitzpatrick. Fitzpatrick owned the Pierce House until 1895, when he was forced to retire due to a severe hip injury. Fitzpatrick suffered a horrific loss while owning Pierce House. An outbreak of diphtheria hit the hotel's guests and staff in January 1884. One child died: Fitzpatrick's son. Still reeling from the death of his child and experiencing a significant financial loss because of the quarantine, Fitzpatrick sent a bill to the city for $1,100, stating it was needed to cover the expense of disinfection and repairs. He was denied. Fitzpatrick decided to spend more time at his farm outside the city, so he stepped away from management, leasing the property. The new owners renamed the hotel Commercial House. They managed it for several years before transferring the lease to A.G. Rich, who reopened it as the Grand Union Hotel. Fitzpatrick sold the building to Warren H. Brown, who reopened it as New Rochester Hotel. The building's room capacity was expanded in 1898 with a rear addition.

John Norton purchased the hotel in 1900 and called it the Rochester Hotel. A *Post & Record* article from November 1900 reported that the Rochester Hotel's new coach, made by Beck & Sons of Cedar Rapids, Iowa, was "one of the most attractive in the city," with an "oak finish, and parts of it are artistically painted and decorated. The inside is beautifully upholstered and finished." The bus taxied hotel guests to and from the

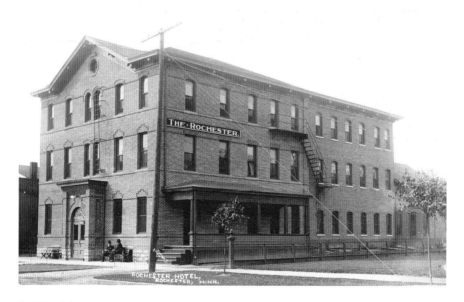

In 1900, John Norton bought Pierce House, renaming it the Rochester Hotel.

railroad depot. Norton enlarged the building by adding another addition, this one made of brick. To give the building a more cohesive look, Norton resurfaced the front of the hotel with veneered brick. The *Olmsted County Democrat* reported in a May 22, 1908 article that the enlargement and addition improved its interior appearance, complimenting the hotel's new staircase as "a thing of beauty and not simply to serve as a means of getting from one floor to the next. Through a large archway the stairway turns from the main hall and descends directly into the office. As it is of hard wood and surrounded by ornamented balustrade, the effect is pleasing." Norton remodeled the hotel entrance, building a covered entrance large enough to accommodate carriages, protecting guests from rain and snow.

From 1920 to 1922, the building operated as a medical facility called Olmsted Hospital. After its closure, nursing students enrolled in Kahler Hospital School of Nursing resided there until 1928. The building caused quite a media sensation when it was divided into three sections and moved by teams of horses three blocks to 426 Second Avenue Southwest. With the move, it gained yet another name: Maxwell House. It operated in this capacity until 1968, when it was sold and renamed the Maxwell Guest House.

The building was added to the National Register of Historic Places on July 21, 1980. Its nomination form described the structure as

> *a three story brick building, 124 feet long, 45 feet wide at the west (front) end and 30 feet wide at the east end, with a stone foundation. A narrow, 28-foot-wide gable roof extends the length of the building, ending in a hip configuration at the rear. A bracketed cornice extends completely around the building. Fenestration consists of symmetrically located one-over-one double-hung sash in rectangular window openings on the first and second floors and segmental arch openings on the third floor.*

Built in the Victorian Italianate architectural style, the only major structural change noted at the time of its nomination was a porch addition encompassing all three stories on the building's façade.

Jim and Norene Elliott purchased the property in 1985 and managed it as a monthly paid residence. The property was sold in 2006 and demolished in 2007.

A COMMITMENT TO EDUCATION

From its earliest days, Rochester placed education as a high priority. Early settlers worked together to provide a school as soon as basic necessities were met for their families. The first schoolhouse was a log building located at the corner of Second Avenue and Third Street Southeast. It was built by community effort; even the school's future pupils were active participants in its construction. Erecting a school was a significant milestone for frontier cities like Rochester. An article highlighting the history of Rochester's schools appearing in an August 1941 edition of *Know Rochester* stated, "The raising of such schoolhouses was an important event and long remembered by the young. The writing board girdled the walls, long, rough benches were arranged in rows and the master's desk so 'fearfully and wonderfully made' occupied the most commanding position [in the center of the room]."

Rochester's first public school teacher was Mary Walker. School was taught in the rustic cabin until 1858. City officials began discussing the need to build a large permanent school as early as 1860, but the Civil War sidelined the idea. The school bounced around to different locations for a few years before moving into the basement of the 1866 Olmsted County Courthouse. Finally, at long last, a large accommodating school building was built.

OLD CENTRAL SCHOOL

An impressive five-story building rose up against the Rochester sky in 1868. The Old Central School was an extraordinary piece of architecture, and it would house the city's public school students until 1926. City residents loved their school. Like the 1898 Central Fire Station, it became one of Rochester's most beloved and monumental buildings. At the time of its construction, it was the city's tallest structure. It opened on May 25, 1868, with Miss M.C. Bateman serving as principal. When fall term started in September, 460 students were enrolled. By November, the start of the school's winter term, the total student population had increased to 700.

Its name derived from its position within the city, on a large lot in the center of downtown, bordered on the north by First Street Southwest, on the south by Second Street Southwest, on the east by Second Avenue Southwest and on the west by Third Avenue Northwest. The school was incomplete when it opened, but the May 22, 1869 *Rochester Post* stated, "The site embraces two and a half acres, and when graded and ornamented with trees, grass plants, and walks and surrounded by a neat iron fence (improvements which are already in process of completion) the school grounds will be ample, neat and delightful."

Horace Cook drew the ground plans and A.M. Radcliff, the same St. Paul architect who designed the Cook Hotel, the elevation plans. The building had a total of fourteen rooms and measured 94 feet by 87 feet and reached 127 feet at its highest point, the top of the large front tower. The *Rochester Post* commended Cook and Radcliff on their project: "While durability, elegance and due proportions have been carefully studied in the outward construction of the building, economy, comfort and convenience are equally secured in the interior arrangements." Filling the building's 136 windows were 1,200 panes of glass. Eight hundred cords of stone, 700,000 feet of brick and 300,000 feet of lumber were used in its construction. The ceilings were high: 10 feet in the basement, 18 feet on the first and second floors, 14 feet on the third and 16 feet on the fourth. In addition to the main tower located on the building's south side, a smaller tower was located on its north. Two pairs of turrets graced the east and west sides. A roof with steep sloping sides topped the structure, and one hundred squares of tin covered the domes of the towers.

There were entrances on all four sides, and each entrance had stone steps leading up to it. Described the May 22, 1869 *Rochester Post*:

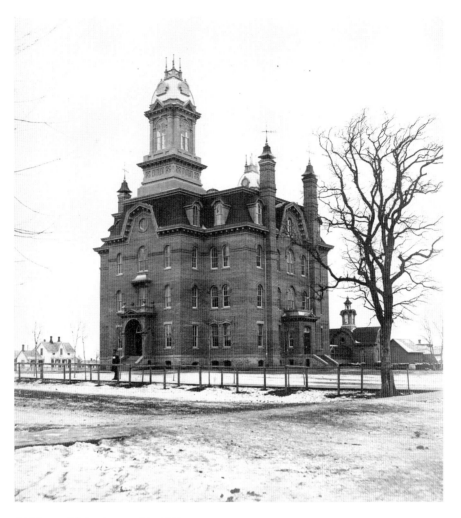

Old Central School opened in 1868.

The north and south doors open into a hall 10 feet wide and running the whole length of the building. At either end of the hall, in the northwest and southwest corners, are the stairs, 6 feet passage, with platform landings and continuous rail. All the rooms on each floor are reached by those stairs; also the towers at the north and south sides of the building. In the southern tower at an elevation of over 100 feet is to be an observatory, looking out at the four points of compass and commanding a magnificent view of the city and surrounding country. The belfry is in the north tower, where hangs one of the finest and richest toned bells in any building in the West.

The bell weighed 1,500 pounds and was casted by the Meneely Bell Foundry of Troy, New York. The words "Public School of City of Rochester, A.D. 1868" were engraved on the iron. William Hein, the school's janitor, ran the bell for four decades. Hein did more than ring the bell. He became a local weatherman, using flags to broadcast weather conditions to Rochester citizens. The south tower, the highest point in Rochester, was used to communicate current weather: a white flag displayed when weather was clear and quiet; a dark blue flag fluttered when weather was stormy.

The bell, which signaled the beginning and end of each work and school day, was destroyed when a devastating fire ripped through the building in 1910. An unknown author contributed a description of what happened to the bell to the History Center of Olmsted County's archives: "As the flames licked furiously on all sides and hot winds rushed hungrily through the tower, the old bell rocked back and forth, tolling its own funeral. Then when it could hold its position in the tower no longer, it broke and fell down, down to the very basement." The heat was so intense that the bell melted. The towers, turrets and the top two floors were also destroyed. The building would not be restored to its previous glory. The lower floors were repaired, a new roof was installed and school resumed; however, an undated newspaper article in the History Center of Olmsted County's archives declared the city was saddened by its new look: "It was found the old outlines of the structure had vanished and instead of a tall, stately edifice, a squat two-story structure was left to remind the former school boys and girls of the glories that once attached to Central School."

The building was sold to Mayo Clinic in the mid-1920s. Students attended school in Old Central until 1926. After the school vacated, the clinic remodeled the building into office space. The clinic also opened a medical museum on the first floor. The building was razed in 1950, and the Mayo Building was erected in its place.

ACADEMY OF OUR LADY OF LOURDES

In 1877, a group of Franciscan Sisters, led by Mother Mary Alfred Moes, arrived with the purpose of organizing a Catholic school. Eight lots were purchased for $2,800 on the north side of Center Street, and plans were drawn to construct a four-story building of brick and stone. The project was helmed by Winona architect C.G. Maybury and contractor C. Bohn. The *Rochester Post* described the structure in a July 27, 1877 article:

There will be a vestibule in the front with a projection of eight feet; also a vestibule on the west side, same size, and both rising to the roof. A neat symmetrical dome at the front will rise thirty feet from the apex of the roof, the dome to be surmounted with a cross, eight feet high. At the opposite end, and also on both sides, there will be turrets, each twelve feet high, with a weather vane.

The building measured seventy-two feet by forty-eight feet. An impressive long hallway, eight feet wide with twelve-foot-high ceilings, stretched from the south-facing entrance to the north end, running the building's entire length. A central staircase curled upward from the hall to the second floor. Another stairway was located just inside the building's west side entrance. The second floor contained several more classrooms, two music rooms and a dormitory. The third story had four large dormitory rooms. The basement held the kitchen, food cellars and dining room. The building's curb exterior was arresting, with a dark red brick body and light stone trimming around the front door, windowsills and caps.

Classes began on December 3, 1877, with 210 students enrolled, 60 of those living onsite in the dormitory. Mother Mary Alfred Moes was the school's director. By August 1878, the school had been legally incorporated to give degrees. For the 1878–79 school year, 300 students enrolled, and the school purchased the nearby St. John's Church Hall. The hall was moved to the academy in 1882 for a cost of $1,239 and renamed St. Mary's Hall. In 1888, a large wing was added to the school. Music and arts classes were held within its walls.

Music was a favorite subject at the school, and due to its popularity, it wasn't long before musical programs were held at the end of the school year. An undated newspaper clipping in the archives at the History Center of Olmsted County reviewed one program favorably, stating, "The program was one of rare merit, many difficult classic compositions being given by the participants, showing talent and ability that has been strengthened by the instruction in the School of Music."

In 1894, the Academy of Our Lady of Lourdes and the Sisters of Saint Francis bought a building in Winona that had housed St. Mary's Academy, a girls' boarding school from 1885 to 1887, followed by the St. John's Hospital. Shortly after the purchase, the boarding school moved to Winona and became the Winona Seminary for young women. The school would eventually be known as the College of St. Teresa, which closed its doors in 1989. The buildings on the Rochester campus continued to be owned by

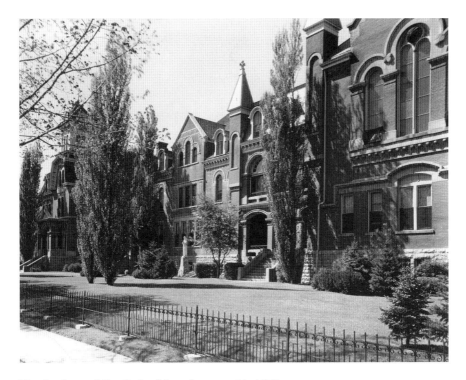

The Academy of Our Lady of Lourdes opened in 1877.

the Sisters of Saint Francis and used for the coeducational St. John's Parish Schools. Starting in 1900, the 1877 academy building was the motherhouse for the Sisters of Saint Francis. The Academy of Our Lady of Lourdes campus buildings at 514 West Center Street were razed in 1955.

ROCHESTER HIGH SCHOOL

For a time, Rochester High School was housed in the Old Central High School. Six students graduated from the high school in 1871. The 1871 diploma read: "For successfully completing the entire Latin, French and English course." The students were Carlton Shephard, Edna Marie Emerick, Mary Furlow, Alice Jenness, Octavia Payne and Ella Rickert. Edna Emerick shared her memories of those Old Central School days in the May 1930 edition of *The Rochet*, a school publication. Emerick talked

about decorating a schoolroom with spring wildflowers for the graduation ceremony and how each graduate gave an oration. In oration practices, Edna was told by her teachers to speak louder, and she recollected that on graduation night, "I must have almost screamed when I spoke that night for one of my teachers, who happened to be late for the exercises, heard me giving my oration when she came into the building; and imagine this, I was talking in a room on the third floor." A few years after graduation, Edna gained employment as a librarian at the Rochester Public Library, a position she'd hold for thirty years.

By 1895, the student population had grown considerably, and it was decided to separate the primary and intermediate schools from the high school, placing them in different buildings. The younger grades would remain in the Old Central School, while the high school would move to a new location. School officials knew that within a few years a new school would be needed to accommodate the growing number of high school students, but a temporary building was needed immediately. Luckily, a suitable location was available, a building owned by Delbert Darling that had housed his Darling Business College for the past eight years. The business college, founded in 1879, was open to both men and women. According to an ad supplement in the November 7, 1879 *Rochester Post*, classes included bookkeeping, penmanship, commercial law, arithmetic, business practice,

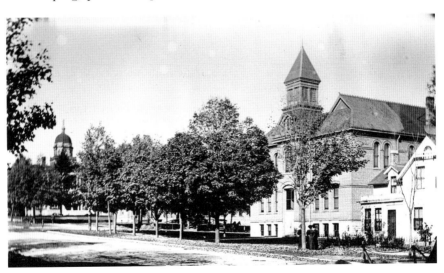

The Darling Business College building became home to Rochester High School in 1895.

spelling, correspondence and phonography. The college was one of many private education institutions within the city, which included Pike's Normal School, Rochester Training School, Rochester Academy and the Rochester Seminary for Young Ladies.

The Darling Business College structure was built in 1883 on a city lot at Second Street Southwest. It was made of brick and was three stories in height, including the basement. The building housed the Rochester Seminary and Normal School from 1883 until 1887. Eugene W. Young, a graduate of Northfield University, operated the school, which was financially supported by the Methodist Church. The property was in Young's possession for four years before he foreclosed on the property when he failed to pay the mortgage. The deed passed to Darling on January 7, 1887. Darling promptly moved his business school into the building, his school having outgrown its rooms above a store in downtown. Enrollment included students from Minnesota, Wisconsin and Iowa. Average yearly attendance was over one hundred. Not long after selling the building to the school district, Darling moved to Fergus Falls in northern Minnesota and opened another business school. The Darling Business College building was torn down in 1910 to make room for a larger high school structure.

While the new high school was under construction, students attended class at a downtown hotel. The first high school class to graduate from the new building was in 1911. An addition was built in 1917 and another building constructed in 1927. This building was given the name New Central School and housed the district's elementary students when they vacated the Old Central School building after Mayo Clinic purchased it. In 1940, when an addition was added to the New Central School, its name was changed to Central Junior High School. The high school building was given the name Coffman. An underground tunnel connected the two structures.

The graduating class of 1889 started a tradition of giving an item to be displayed in the school. These gifts included a portrait of Abraham Lincoln; busts of George Washington, Napoleon Bonaparte, Benjamin Franklin and William McKinley; a statue of Hiawatha; and a large clock. In 1937, Helmer Lindbeck was commissioned to paint a colorful mural, seventy-two feet long, of the Dubuque Trail for the high school's library. The mural, funded by the Federal Arts Project, was placed along the library's west wall.

The school's colors were introduced at an 1897 football game between Rochester High School and St. Charles High School. According to recollections of Bunn T. Willson in the History Center of Olmsted County archives, students attending the sporting event stopped at a store in St.

Charles and purchased colorful ribbons, which they displayed at the game. St. Charles won that September game, but a rematch was planned on Thanksgiving Day at Rochester's county fairgrounds. And the colorful ribbons were remembered. Rochester High School students attended the game wearing their adopted colors of red and black. Willson recalled, "The Red and Black was in great prominence. A large flag of this favorite 'color' waved in the breeze near the ticket office, and EVERY student proudly wore streamers of ribbon in the red and black." Rochester won the game, perhaps because of the united school spirit and the formation of a school identity.

A new high school campus was constructed in the northwest section of the city in 1958, and Rochester High School became John Marshall. The city gained a second high school, Mayo High School, in 1966, and Century High School was built in 1997. The old Central Junior High School and Rochester High School's Coffman Building were sold in the early 1980s and demolished shortly after.

WARD SCHOOLS: NORTHROP AND PHELPS

A few years after the large 1868 Central School was built, the city constructed four ward schools to accommodate the growing student population. The first was the Third Ward School, located in the northwest part of the city. The second was the First Ward School, built in the southwest. The third and fourth schools were Holmes and Hawthorne.

The Third Ward School, eventually called Northrop School, was built in 1876 at a cost of $3,800. Horace Ebenezer Horton designed the two-story frame structure. Horton planned many buildings in Rochester, eventually doing a significant amount of work designing bridges in Olmsted County and in other states. The structure was located on the corner of Seventh Street and Second Avenue Northwest. A 1976 school centennial program described the first building: "It was ornamented with heavy scroll work. The front of the building was surmounted by a tasteful belfry. The doors were grained and the sash painted red. The doors were unique in that they opened outward. The interior was a light drab color, trimmed with a darker shade. The floors were white ash strips and the lower part of the walls wainscoted. Woodwork was painted in imitation oak." There were 104 students enrolled during the school's first year. Mrs. Sadie V. Keith and Miss Mary Johnson

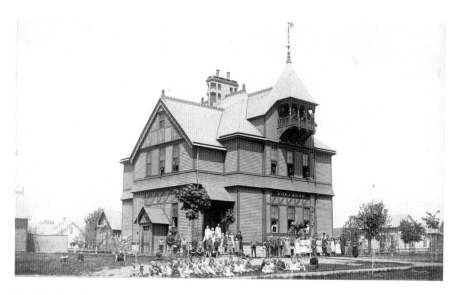

The Northrop School was rebuilt after the 1883 cyclone.

were the school's first teachers. Higher grades, those above third, were taught on the second floor, while the lower grades occupied the first level.

The 1883 cyclone completely destroyed the building on August 21. The school was rebuilt in 1884 at a cost of $7,000. Horace Horton drew the plans for the two-story building. Each floor had two rooms instead of a single space. According to the school's centennial program, "The old foundation walls of the south, east and west sides were utilized in the new building, but the north wall was to be moved out to increase size."

By 1890, the school had changed its name from Third Ward School to Northrop School. The moniker was in honor of Cyrus Northrop, president of the University of Minnesota. Northrop, a Yale University grad and Connecticut native, would serve in this position a total of twenty-seven years, from 1884 to 1911. He is widely credited as being an influential factor in the university's rise to a top-ranking academic institution among the nation's state research universities. He quickly became a well-known and respected figure in Minnesota. According to his biography on the University of Minnesota website, Northrop "won the hearts of students, faculty, and the people of the state." Mount Northrop in the state's Sawtooth Mountains along Lake Superior's North Shore is named for him, as are the small town of Northrop in southwestern Minnesota and the Cyrus Northrop Memorial Auditorium on the University of Minnesota campus.

On February 10, 1891, a devastating fire ripped through the building, putting 160 children and staff in danger. John Weinrebe, the school's janitor, was credited with discovering the fire and quickly taking action, helping escort children and teachers out of the building. Incredibly, no one was hurt, something the *Record & Union* attributed to the teachers' fire drill training. The *Daily Post* reported, "Many mothers in North Rochester were terror stricken this morning when they realized the Northrop School was on fire and their little ones might be at the mercy of the relentless flames. Many of them were seen running towards the building in half a frenzy and it was with great relief that they welcomed the children safe from the flames." The fire caused significant damage, but within two weeks, repairs had been made and students and teachers filed through its doors again.

A new school building was constructed in 1915. This building held eight rooms and was built at a new location, at Second Avenue and Eighth Street Northwest. An addition was added in 1935. The building is now known as the Northrop Community Services Center, the headquarters of Rochester Public Schools Community Education. The site of the old school was sold in 1919, and the building was demolished.

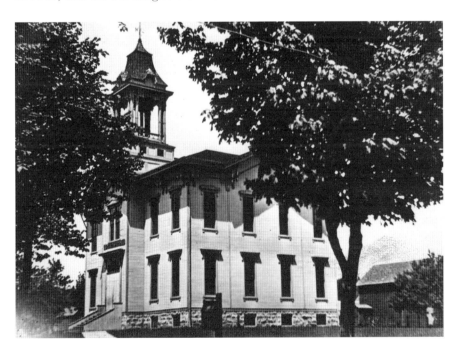

Phelps School.

The two-story public school in Rochester's First Ward opened in 1877 and was named Phelps School sometime before 1900. The school was named for Minnesota educator William Franklin Phelps. Phelps was president of the Winona Normal School for teachers in Winona from 1864 to 1876. Winona State University's Phelps Hall, which housed a normal school, is named in his honor. He was a longtime educator, having started teaching at the age of seventeen in his home state of New York. He authored many textbooks and education training materials and was president of the American Normal School Association for forty-four years, from 1856 to 1900.

Horace Horton also designed the four-room Phelps School. The contractor managing the project was L. Andrus. While both the 1876 and 1877 Northrop School buildings were praised as being well built and beautiful, the Phelps School was criticized for being less than stellar. When a fire destroyed the building in 1915, the *Daily Post & Record* was harsh in its assessment of why the building may have surrendered to the fire so quickly:

> *Just who was to blame for the nature of the construction of the building is not known, but it is certain that the walls were not substantial, the chimney was not substantial, and those who knew the state of the structure, assert that a good heavy gust of wind might have toppled the walls over. In fact, during the fire, walls fell out, not because they were burned, but because there was nothing substantial holding them together.*

Interestingly, just a few weeks before the disaster, the school failed an inspection conducted by Rochester fire chief William Letford after he "found several conditions that were deplorable," including the lack of required fire escapes. The school was not rebuilt, and the Rochester Public Schools Edison Building sits at its location.

DEDICATED TO CIVIC DUTY

The early settlers who chose Rochester as their permanent home proved to be civic minded, working immediately to organize city government and other public service institutions. Earning the coveted county seat prize in 1858 expanded and enhanced that dedication, and over the decades, many unique municipal buildings were built.

BROADWAY HOUSE

Rochester vied to be the county seat with Oronoco to the north and Marion to the southeast. It was a heated competition among the communities, and Rochester proponents knew having a courthouse would secure victory. However, there was a lack of funds to construct such a building. Charles Lindsley stepped forward and offered to loan a building for courthouse use. A long-term lease was agreed upon at a fee of $400 a year, and when the state legislature decided Rochester should be the county seat, Olmsted County's first courthouse opened in what would eventually be known as Broadway House at 301 North Broadway. The county rented Broadway House from 1858 to 1867. County offices and a public hall were located on the first floor, a courtroom and meeting halls were on the second and school was conducted in the basement.

Nick Peters bought the property from Lindsley shortly after the county built a new courthouse. He would own Broadway House until his death in

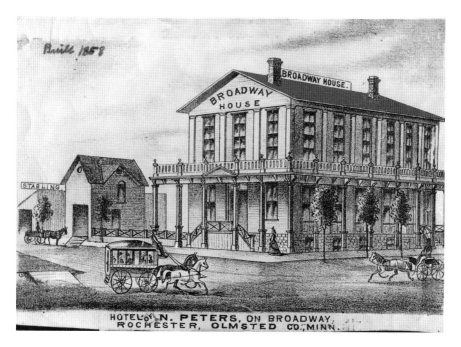

Broadway House served as the city's first courthouse.

1893. During his tenure as landlord, the building operated as a hotel and served for a time as a Turkish bathhouse. Broadway House gained quite a reputation as an excellent bathing house. A June 29, 1877 *Record & Union* article claimed the manager, a Mr. Atwood, had "fitted the place up in fine shape, and those who have taken baths in larger cities pronounce this as fully equal to the best bathing places, in every respect." Turkish bathing houses were thought to help with various medical ailments and were popular during the late 1800s. The *Record & Union* described Rochester's reputable bathing house:

> *There are four apartments, the first being the dressing room in which the bather prepares himself for what follows. He divests himself of all clothing and is wrapped in a sheet, when he is conducted to a room, which is heated to about 120 degrees. Here he remains until perspiration commences to flow, when he is taken to a third room, which has a temperature of from 160 to 175* [degrees], *according to the condition, or ability of bathers to stand it.*

After the "sweating room," patrons moved into a room where they laid down on a marble slab and received a body massage, which stimulated the body's blood flow, helping to strengthen and add flexibility to joints and muscles. After the massage, clients bathed and dressed, leaving the establishment feeling much more relaxed and possibly far less achy.

In November 1881, a fire damaged the building. Another fire burned part of the structure on April 3, 1892, and Mr. Peters quickly rebuilt. Mrs. Margaret Lawler purchased it in 1899 and leased it to Mrs. R.V. Russell and Mrs. W.H. Mackey. The two women renamed the hotel Northwestern Hotel. The property was sold to Adolph Ridge in March 1909. In 1911, Sam Sternberg leased the hotel and courted Jewish visitors, adding a kosher lunch counter. After purchasing the hotel, Sternberg hired Ellerbe & Co. of St. Paul to design a new building in place of the 1858 structure. The 1919 hotel held more guest rooms and a restaurant. Verne Manning purchased the hotel in 1944 and renamed it Avalon Hotel, offering accommodations for African Americans visiting Mayo Clinic during the 1940s, '50s and '60s. It was listed in the National Register of Historic Places in 1982.

OLMSTED COUNTY COURTHOUSE

The Olmsted County Board of Commissioners started planning for the new Olmsted County Courthouse in 1864. The county purchased three acres of land at the corner of Sixth Avenue and Second Street Southwest at a cost of $800. The total amount allocated for the project was $32,000. The county voted on a tax to help fund the courthouse. However, no new tax was levied, and the money was obtained by a combination of delinquent taxes gathering in the county's treasury fund and from interest gained on other county funds. The completion of the three-story Italianate brick structure with limestone trim was delayed by a year due to significant rainfall during the summer of 1866. The *Rochester Daily Bulletin*'s August 17, 1867 article gave a detailed description:

> *The main building, including the wings, occupies a space of 68 feet by 98 feet in depth. The building above the basement is two stories in height; the first being 16 feet between floor and ceiling, and the second 21 feet 9 inches. The extreme height of the building from ground line to base of dome is 58*

feet. The dome is circular in form, 18 feet in diameter at the base and 46 feet high, making the whole height from the ground line to the top of the dome 104 feet. The ascent to the interior of the dome is safe and easy, and when gained, a view of the city and surrounding country is had, for beauty and grandeur, is not easily excelled or described.

The paper went on to describe the first floor's twelve-foot-wide hall, with multiple county offices lining each side and an impressive double elliptical stairway leading to the second floor. Once ascending to the second floor, visitors walked through a lobby before entering the fifty-one-foot by sixty-foot courtroom. J.H. Grindall of St. Paul was the contractor of the project, and Augustus F. Knight of St. Paul created the final architecture plans. However, locals gave credit to Warren Hurlbut, chairman of the Olmsted County Board of Commissioners, for sketching the building's original design. Knight also designed the Washington County Courthouse in Stillwater, completed in 1870. The building was nearly identical to Rochester's, except it was larger. The building still stands at 101 West Pine Street and is used as a venue for private parities and community events. It is listed in the U.S. National Register of Historic Places.

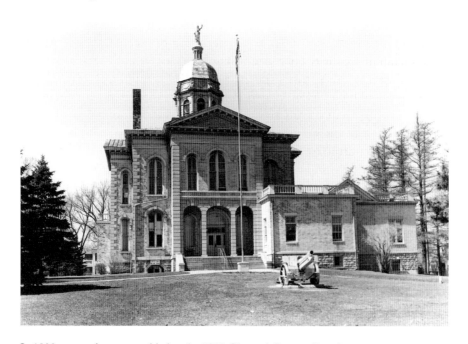

In 1892, a new dome was added to the 1867 Olmsted County Courthouse.

When the 1883 cyclone ripped through Rochester, the courthouse was not spared from its destructive wrath. The beautiful dome atop the building buckled under the pressure of extreme winds, collapsing and tumbling through the roof and crashing into the interior. It wasn't until 1892 that a new dome was erected in its place. A December 16, 1892 *Rochester Post* article reported the new dome was designed by Maybury & Son of Winona at a cost of $2,600: "A highly decorated dome surmounted by a statue of Justice, the whole being forty-seven feet in height, will be erected, and will add greatly to the appearance of our courthouse. The dome will be octagonal in form, covered with galvanized iron in imitation of brick and stone. The ornaments will be covered in gold leaf, as will also the scales and the sword of the statue."

The statue crowning the dome was a metal effigy of the Greek goddess Themis, the goddess of law and order. Themis was the daughter of Uranus (god of the heavens) and Gaea (mother of Earth) and was the second wife of Zeus. Themis held weighing scales in one hand and a sword in the other, a common depiction of the goddess. The scales represented justice's fairness and balance, weighing the claims of opposing sides equally to reach an accurate judgment, and the sword represented the harsh punishment administrated to violators, keeping law and order.

The courthouse was demolished in 1958, but Themis was rescued and placed into storage. After nearly seventy years on her perch, she wasn't as resplendent as she'd once been. The gold leaf weighing scales were missing, lost in a 1920s storm; the once gleaming metal was tarnished; and she had several bullet holes lodged in her surface, acquired from an effort to discourage pigeons from roosting. She was moved to storage during construction of the new courthouse. The plan was to move her to a pedestal near the new courthouse's parking lot; however, it was decided that might put her at risk for vandalism. So she stayed in storage for several years and was glimpsed briefly in an outdoor county storage lot in 1960 before resurfacing at the History Center of Olmsted County, where she received restoration work. In 1972, she finally was placed on the courtroom's third floor, where she stayed until 1992, when the present Olmsted County Government Center was built. In July 1993, Themis arrived at the Government Center, carefully hoisted by crane and gently lifted through a fifth-story window. She resides near the building's courtrooms, the last surviving remnant of Rochester's first courthouse.

ROCHESTER PUBLIC LIBRARY

The origins of the Rochester Public Library began in December 1865, when the Rochester Library Association was organized with J.D. Blake as president. The group started a subscription service supplied by donated books. Eventually, $1,000 was raised through subscriptions, allowing the purchase of additional books. The library depended on donated materials, donated space and volunteers. Magazines were added in 1872 and newspapers in 1873. In 1876, a free reading room, encouraging reading by giving people a quiet space to read books and other print materials, was established in the basement of the post office located at 25 Second Street Southwest. According to the *Rochester Post*, it was well patronized and averaged about seventeen visitors a day, occasionally reaching upward of forty. In August 1876, the *Post* reported the reading room and library moved above W.W. Ireland's store at the corner of Broadway and Second Street Southwest. The Rochester Library Association became the Free Library and Reading Room Association, with Mrs. John Edgar as president. The first librarians included Louis Walker, C.C. Jones and Carrie Lockwood, the first female librarian. Edna Emerick became the librarian in 1885, remaining in this role until 1924.

The library's inventory steadily expanded during its first few years. *The Catalogue of the Rochester Public Library for the Year 1881* included the works of Charlotte Bronte, James Fenimore Cooper and Charles Dickens. Also listed were books about European queens and kings and histories of France, Egypt, Japan, England, Rome and Greece. There were also a variety of plays and philosophy and science books.

The first library board was formed in 1895. That same year, George Healy donated $5,000 for the purchase of books. However, there were stipulations attached to the gift. In a letter written to the library board on November 2, 1895, Healy stated, "I desire that the library shall also contain books and reading matter of a liberal nature for the benefit of those who may desire to use them, and I therefore desire to annex, as a condition of my donation, that no book shall be excluded from the library by reason of its religious tendencies." He mentioned purchasing the works of Thomas Paine and Robert Ingersoll, both controversial philosophical figures who questioned God and organized religion. Local church leaders were not pleased at the idea of having such material available, but the library board agreed to Healy's request. Another big event for the library during 1895 was its move to the second floor of

Rochester City Hall, located at the corner of First Avenue and Third Street Southwest. Also in residence at the city hall were the sheriff's office and city jail. The Richardsonian Romanesque structure, built in 1884 at the cost of $25,000 and razed in 1931 to make room for a new city hall, housed the library for the next three years until it moved into its own building.

The 1898 Rochester Public Library was located at Second Street and First Avenue Southwest and cost $15,000. The city paid $10,000, and resident Huber Bastian donated $5,000. Like Rochester City Hall, the building was designed in the Romanesque Revival architectural style with rounded arches atop its upper-floor windows and an exterior composed of Lake Superior sandstone, Menomonee pressed brick and a slate roof. Minneapolis architect Charles Sedgewick was awarded the project, but library board members Walter Hurlbut and Burt W. Eaton drew the first sketches and consulted with a Minneapolis librarian on its design. When the library moved to its new home, its collection had grown to over three thousand books. The library opened to the public on March 1, 1898.

The library's entrance was located on Second Street. The *Record & Union* previewed the building in its November 26, 1897 issue, stating:

> *Entering through the heavy oak doors we find ourselves in the vestibule, with its pretty tiled floor and frescoed walls, pushing open the swinging glass doors we enter the main room, which is beautifully decorated. A broad oak stairway leads from here to the rooms above. The walls are done in frescoes in terra cotta shades. The librarian's desk occupies the rear portion of the room. The decorations are very classical, the ceiling being supported by Doric pillars.*

The interior possessed wide hallways, dark wood trim and rooms with arched doorways. In addition to several reference rooms on the first floor, the children's room occupied the floor's southwest corner and a blue reading room with chairs and tables and magazine and newspaper racks was in the northwest corner. The second story consisted of two rooms with seventeen-foot ceilings. The smaller room was to be used for library board meetings, while the larger, measuring thirty feet by twenty-six feet, would display pieces of art. The building was equipped with gas electric lighting. The library's basement had an area for book repair, complete with a dumbwaiter for delivering books up to the librarian's desk, hot-water heaters, two bathrooms and a janitor's room.

Left: The 1884 Rochester City Hall.

Below: The Rochester Public Library building opened in 1898.

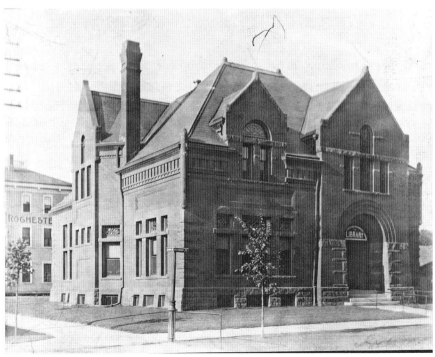

The library dedication was held on March 3, 1898. An orchestra began the event with "Selections from the Serenade," even providing an encore. A prayer and a welcome address by the library board's president, Burt W. Eaton, followed. Several other speakers took the stage, including Dr. J.K. Hosmer, librarian of the Minneapolis City Library, who focused his talk on the importance of a library and its positive impact on communities.

When longtime board member Walter Hurlbut died in 1904, his widow bestowed the library with a $15,000 trust fund to create the Walter Hurlbut Book Fund in honor of his dedication and service to the library. This substantial gift helped fund many library needs for several years.

The Rochester Public Library vacated its first official home in 1937, moving into a Harold Crawford–designed limestone building at the corner of Second Street Southwest and Third Avenue Southwest, which now houses the Mayo Clinic Medical School. After the library moved out, the building served several purposes, including as a World War II military recruitment center, a performance venue for the Rochester Community Theater and a home to the Rochester Art Center. It was demolished in February 1948.

ROCHESTER FIRE DEPARTMENT STATIONS

Rochester's booming economic development and population growth between the years 1854 and 1866 generated great concern about fire danger among residents and business owners. Their worry was justified. Many fires swept through the city's business district. Downtown, with its wood-frame buildings built side by side, sometimes without even a space between them, provided the perfect environment for flames to spread quickly from one building to the next. Local newspapers published articles demanding a fire department, and the first Rochester Fire Department building was constructed in 1870.

The building, located on the west bank of the Zumbro River and placed directly over the millrace so its steam pump had unlimited access to water, was enthusiastically welcomed. The two-story frame building with white-painted clapboard siding was a beacon of safety to the fire-jittery citizens. It was thirty-one by thirty-one feet and twenty-one feet high, with a tower reaching fifty feet. A traditional water pump was placed in the Olds & Fishback Mill nearby, powered by the large water wheel. However, the station's prize was a new portable steam pump. The Silsby Manufacturing

Rochester's first firehouse was built in 1870.

Company of Seneca Falls, New York, produced "The Little Giant." In the *History of the Rochester Fire Department 1866–2000*, authors Minard Peterson and Betty and Elmer La Brash give a beautiful description of the industrial contraption:

> *The heart of the 3,600 Little Giant was an upright cylinder of German silver and brass. Inside was a tubular boiler more than 7 feet high and 39 inches in diameter. In front of the cylinder was a compact engine of brass and steel. The boiler contained 174 steam tubes and 63 smoke flues ranging up to 2 inches in diameter. It promised to provide a maximum 140 pounds of steam. The polished engine and pump sat horizontally on an iron frame painted red and was liberally supplied with silver lanterns. Around it rested a large suction hose. By all descriptions it was a superb apparatus, remarkably compact and constructed with an eye to beauty. The machine hung from spiral springs and ran on four iron-braced wheels. Men or horses could pull it.*

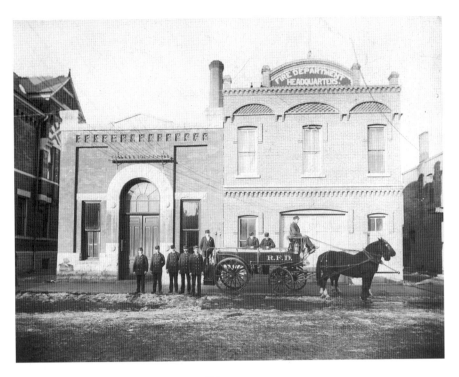

The Rochester Fire Department, circa 1890.

"The Little Giant" often remained on the first floor of the firehouse, providing enough pressure to channel water from the Zumbro River through one thousand feet of hose. If a fire erupted farther away, it could be pulled to that location.

In 1890, the fire department exited the building and moved into a new two-story brick fire station on Third Street Southwest, next door to the city light plant.

In 1898, a new fire station added impressive distinction to the Rochester skyline. The previous two stations had served Rochester well, but this building possessed many modern amenities and was a uniquely designed and beautifully crafted piece of architecture, the crème de la crème of all the city's buildings. Designed by John M. Doherty and contracted by C. Olson Lee, it instantly became a beloved centerpiece of Rochester. It sat at the south end of Broadway at the corner of Fourth Street and would eventually find itself sitting directly in the middle of the street when the city grew and expanded south, the roadway circling around on either side. It was its location that sealed its fate thirty-two years later when it was

decided Broadway would become part of U.S. Highway 63. To create a less congested and faster throughway through the city, the magnificent structure was obliterated in 1930.

The Central Fire Station was an impressive sight. The *Olmsted County Democrat* declared it "the prettiest headquarters for a fire department in the state" in a December 15, 1898 article about its opening dedication. And indeed it was. The building was completed in just five months. It was sixty-four feet by forty-four feet, with a stable, measuring twenty feet by twenty feet, on its south side. The stable housed many horses, including Prince, Chief John Boylhart's black horse, a familiar sight around town; the prancing steed transported Boylhart to and from fires in a small wagon. Horses were discontinued shortly after with the arrival of the station's first motorized fire truck in 1912. Two garages on its east and west sides housed vehicles and other equipment; the wide doors opened and closed electrically.

The fire station was red brick with limestone trim, and two second-floor balconies, each framed with white wrought-iron scroll arches, enhanced its façade. The *Olmsted County Democrat* stated, "The large windows look out upon broad balconies, each as large as an ordinary parlor. The view down Broadway is quite enchanting. These balconies will make an excellent place for public speakers, being located where a large out-of-door audience can assemble conveniently." Into the center of the first floor descended a steel fireman's pole. A large oak staircase stood directly behind it, ascending to the second floor, where a hall, used for dancing and social events, and firefighters' sleeping quarters were located. The entrance to the building's tower was also located on the second floor. It was this impressive extension that truly gave the fire station its awe-inspiring grandeur.

At eighty-five feet in height, the station's clock tower ascended regally toward the sky, an impressive addition to the city, and one that quickly became a defining feature of the skyline. The clock cost $3,500 and was crafted by the Seth Thomas Clock Company of Connecticut, one of America's oldest and most respected clock companies, known not only throughout the country but throughout the world. The company traced its origins to 1813 and gained fame during the mid-1800s by being the first to mass manufacture clocks, making them affordable and available to everyone despite social standing. The Seth Thomas Clock Company also designed the clock adorning the information kiosk in the center of New York's Grand Central Terminal's main concourse and Independence Hall's 1876 Centennial Clock in Philadelphia. The company's first clock

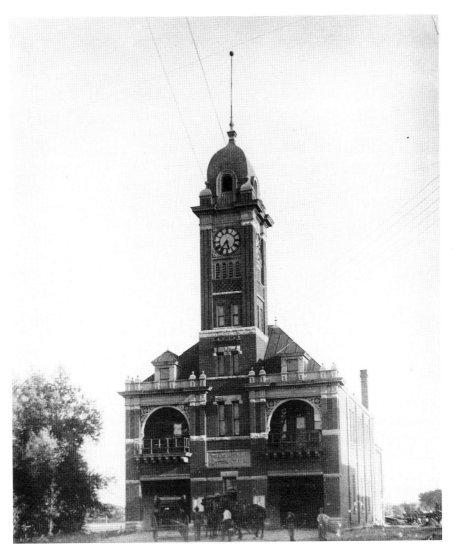

The 1898 Central Fire Station.

tower was made in 1872. The company would gain status as one of the world's most prolific tower clock producers.

The Central Fire Station's clock had four faces, which could be seen above the rooftops from any direction in the city. The reverberating chime of the 1,200-pound bell marked each hour, changeless and reliable, a regular and forever constant element of daily life for Rochester citizens. Firemen also used the bell to signal a fire. When the Central Fire Station

was razed, leaving a forlorn emptiness in the sky, the clock and bell were saved. Restored in 1982, the historic timepiece was installed outside the Mayo Civic Center, where it stood until 2015. An extensive convention center expansion project made it necessary to remove and place the clock in storage, and its fate was unknown. However, a fundraising campaign called Bring Back the Clock Tower, led by the Rochester Fire Department and historic preservation advocates, began shortly after its removal; the plan is to reinstall it near Rochester Fire Station #1, on the corner of Sixth Street Southwest and Broadway, as close as possible to the original location of the Central Fire Station. Perhaps Rochester will again hear its hourly toll, a historic artifact offering a welcome connection between the past and present.

ROCHESTER POST OFFICE

Rochester's first post office began with the arrival of a U.S. Mail route, courtesy of the Dubuque Trail. The postmaster was Robert McReady, and his rustic cabin was a combination residence, stagecoach stop, inn, store and post office. In 1912, a post office building was constructed at First Avenue and First Street Southwest.

The building's façade was decorated with four stately columns. The columns, of Corinthian order and capped with decorative capitals of sculpted leaf design, supported the horizontal architrave beam, wide flat frieze and cornice molding. Smaller Doric columns and a triangular pediment framed both entrances. The pediment above the front door was more impressive, being slightly larger with ornamental relief sculpture work that complimented the decorative capitals. Large symmetrical arched windows flanked the front access on each side, and a much smaller but identically shaped window sat above the pediment. A panel of tall windows lined each side of the red brick building as well, allowing for generous light to flow through the building. The post office moved out of the building and into a new one in July 1934. The Works Project Administration had offices in the building during the Great Depression. Ironically, the building owed the end of its post office run to a $2 billion federal work relief project bill that funded construction of the new post office. The bill funded many buildings in southeastern Minnesota. The communities of Kenyon, Wabasha, Caledonia, Preston, Kasson, Chatfield, St. Charles and

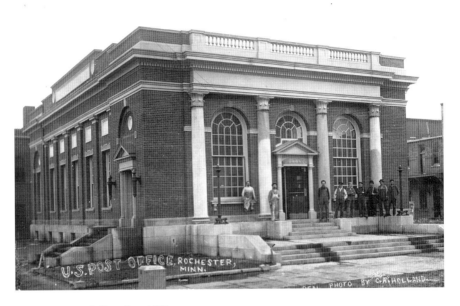

Rochester Post Office, circa 1912.

Zumbrota all benefited from the funds. The 1912 building was demolished in 1938; the 100 First Avenue Building stands in its place.

The new post office was a two-story Classical building made of Winona granite and stone. First Street Southwest, Third Avenue Southwest, West Center Street and Fourth Avenue Southwest framed the building, today a location of a Mayo Clinic parking ramp and grassy outdoor space, directly across from the Gonda Building. Harold Crawford and John Mc G. Miller were the architects, and the G. Swartz & Company of Rochester was awarded the contract. The first floor boasted sixteen thousand square feet. Three entrance doors fronted the building on the south side. Patrons walked into a generous lobby with several writing desks lining the center. Directly across from the entrance were the customer service mailing windows. A stairway led to second-floor offices.

One of the most unique elements of the building was added three years after its opening. A three-panel canvas wall mural was placed on the west wall of the lobby. Minneapolis artist David Granaham was the designer. He was one of 1,200 artists nationwide hired during the Great Depression to create post office murals and sculptures. According to an undated *Post-Bulletin* article from the archive files at History Center of Olmsted County, Granaham's first idea for the painting was to focus on Rochester's medical

history, but Dr. Charles Mayo put a stop to that, telling the artist to avoid Mayo Clinic and instead choose another historical event significant to Rochester. Granaham took Mayo's advice, and his oil painting showed early settlers watching as a team of oxen dragged Broadway. Granaham titled his work *The Founding of Rochester*. Granaham painted the canvas panels in his private studio, and on October 3, 1937, Granaham, his wife and an assistant worked from 7:00 a.m. to 10:00 p.m. to adhere the three panels to the wall. When the building was torn down in 1978, Brad Linder, curator at the History Center of Olmsted County, saved the panels from destruction. It was quite the effort, considering he was given only three days' warning about the demolition. But his efforts to preserve it were worth it. The mural is on permanent display at the History Center of Olmsted County.

APPRECIATION FOR THEATRICAL ENTERTAINMENT

In the early 1900s, Americans gathered as a collective unit in theaters, amused by the song, dance and comedic talents of vaudeville stage performers and delighting in the silent moving pictures, thrilling to the live orchestra's accompanying dramatic score. And Americans' appetite for movies only increased with the release of the first "talkie" feature film in 1927, *The Jazz Singer*. In response to this nationwide passion, towns, both big and small, built theaters, sometimes referred to as movie palaces because of their extravagantly themed décor. Rochester was home to several beautifully decorated theaters. The most well known is the Chateau Dodge Theatre located at 15 First Street Southwest.

The 1927 building, with an interior designed to give moviegoers an "atmospheric" experience of being in a fourteenth-century French village at night, under a starry midnight blue sky, still stands, although the area around it has changed. First Street Southwest no longer passes its front doors. In its place is a community green space. Modern buildings rise on either side. It has faced threat of extinction from the time its doors closed in 1983. The Chateau sat vacant until 1994, when Barnes & Noble moved in. The bookstore was welcomed with great enthusiasm and was one of the most unique Barnes & Noble stores in the country. Residents, visitors and patients were sad to see it close on December 31, 2014, when its lease was not renewed. Everyone wondered: what would happen to the unique and beloved Chateau? The distinctive building sat on prime real estate for developers wishing to capitalize from Destination Medical Center. Many

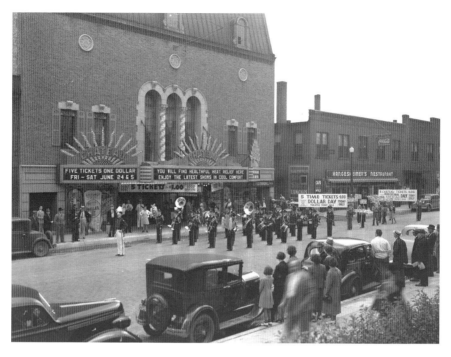

First Street Southwest once ran in front of the 1927 Chateau Dodge Theatre.

A film projection booth was located above the Chateau's second-floor balcony.

worried if one of the oldest and most beautiful buildings in Rochester would finally meet the wrecking ball's wrath. Hearing the community's call for preserving the theater, and realizing its importance to Rochester's history and to its future, the City of Rochester purchased the building, and plans are in the works to preserve and rehabilitate it, turning the historic theater into a multi-use performing arts center and restoring it to a semblance of its original purpose. The Chateau was lucky to survive long enough for a rebirth, but many other Rochester theaters were not, vanishing long ago.

METROPOLITAN

For a short time, from 1885 to 1889, Rochester's entertainment center was the Palace Opera House, also known as Clark's Opera House and Morton's Hall. After its closure, Rochester residents wondered when the city would have another entertainment venue. J.E. Reid, a Rochester jeweler, answered the call and built the Metropolitan at 102 South Broadway. Designed by architect Martin Heffron and quickly nicknamed "The Met," the theater opened to much excitement on Monday, February 10, 1902, with its 8:00 p.m. show, *The Chaperons*, a comedic romp performed by a nationally acclaimed vaudeville troupe. It was the social event of the season. Men wore their best suits, and women donned glamorous evening gowns. After purchasing tickets at the box office and picking up souvenir programs, the audience filed into the spacious theater, escorted to comfortable plush seats by eleven ushers wearing dark suits with red roses in their lapels.

The next day's *Post & Record* declared "the theatre a gem, the opera a treat, the audience delighted, J.E. Reid entitled to all the credit" and enthused about the décor: "One notable feature in the decorations is the lack of anything gaudy and glaring, the effect being dainty, harmonious and pleasing to the eye. Exquisite taste was shown in this matter."

Another unidentified newspaper clipping from the History Center of Olmsted County archives concurred:

> *The decorating, which is simple, but artistic is a credit to the decorators, William Eckert & Co. of Chicago, and it was duly admired last night. The ceiling is painted in light harmonious tints with free hand floral design. The large panels of the side walls are in red with borders of gold leaf.... The electric light system is almost perfect, being thoroughly modern and*

adapted to all the requirements of an up-to-date theatre. The drop curtain excited favorable comment, being a representation of flowing draperies and a scene in Naples.

The theater entranced the audience despite having many unfinished artistic touches. Patrons were thankful to Reid for his dedication to giving the community a modern, comfortable, beautiful and reputable theater. He opened the $40,000 three-story red brick building a mere four months after starting construction. Workers labored day and night to finish as much as possible for opening night. Because of this gratitude, the theater's uncompleted adornments didn't deflect from the appreciation of its exquisiteness. The *Post & Record* determined, "The beauty of the interior will be further enhanced when the grill work and draperies are introduced in the arches between the audience room and the foyer, and the painting and other features of embellishment are finally completed."

Although the theater itself caused much excitement, the evening show was highly anticipated. *The Chaperons* was widely traveled and favorably reviewed

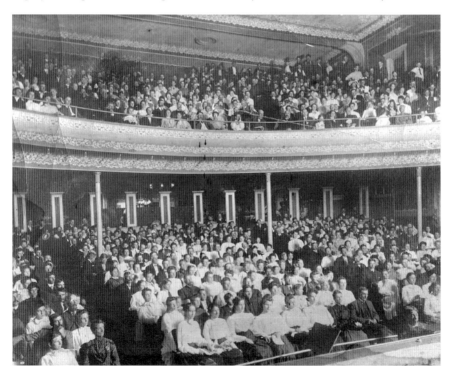

The Chaperons opened the Metropolitan on February 10, 1902.

across the country. Once it had been announced that *The Chaperons* would open the theater, the local newspapers ran national reviews in their editions leading up to the performance. Theater patrons were not disappointed, and the *Post & Record* wrote that the play "proved all that has been claimed for it. From the raising of the curtain until its final lowering, the audience was delighted with superb acting, exquisite singing, rich comedy and abundant music." The show's plot premise was a weak one and not highly regarded, but the dancing, singing and acting of the troupe members overshadowed that detail. Act one begins in Paris at the "English and Continental Order of Trained Chaperons." A young American heiress, Violet Smilax, studying at the school falls for an unsuitable man named Tom Schuyler. Her wealthy uncle Adam arrives to dissolve the relationship. The seal on Adam's will is broken, which results in the characters traveling to Alexandria, Egypt, in act two. There they meet Phrosia, an amateur sleuth. She's on the case of a missing seal—the live animal kind. Say what? Exactly. *The Chaperons* consisted of several head-scratching illogical events wrapped into an incohesive narrative, which various reviewers ridiculed for its lack of substantial plot. But the audience loved the stellar cast performances.

French Canadian actress Eva Tanguay played Phrosia. She had gained high acclaim for her role and was vaudeville's rising star. Andrew Erdman writes in *Queen of Vaudeville: The Story of Eva Tanguay* that "in her role, Eva wore a thick, dark skirt, a cream-colored, college-girl sweater, crude vagabond boots, a felt hat like a gnome's with a brim and high peak, resembling an absurd Halloween adornment. Around her neck was slung a copy of *Old Sleuth*, a collection of detective stories popular with readers in the United States in the 1870s. Her chubby, girlish face and mad laugh completed the effect." The *Post & Record* called the musical number "She Couldn't Say No," sung by Miss Nellie Follis in the role of Violet Smilax, "probably the most pleasing vocal number, and the dancing of Miss Eva Tanguay and Miss Mae Stebbins the most enjoyable feature of the terpsichorean part of the performance. The company was liberal in responding to encores repeating any portion of the bill that met with approval."

Reid was applauded and cheered during the intermission. The Metropolitan proved a roaring success, and Rochester residents looked forward to many years of fine entertainment. They were not disappointed. During its tenure, the Met hosted a variety of famous stage performers, including Otis Skinner, Walker Whiteside, Maude Adams, John Drew Jr. and Fiske O'Hara. The venue hosted the Minneapolis Symphony Orchestra, boxing and wrestling matches and various locally produced plays. Public

speeches were also a highlight, such as from politician William Jennings Bryan and Carrie Nation, a vocal leader of the temperance movement, during its inaugural season.

Motion pictures became a big draw, and one of the first silent films shown at the Metropolitan was 1915's *Birth of a Nation*. The film ran a weeklong engagement during the week of January 9, 1915, being shown at a 2:15 matinee and at 8:15 p.m. Moviegoers received an impressive eleven- by fourteen-inch souvenir booklet containing a biography of D.W. Griffith, the film's director, a seven-page review of the film and historical background and interesting facts about the film, such as that it contained five thousand scenes, used three thousand horses, employed 18,000 people, cost $50,000, included a musical score of forty pieces and used 12,000 feet of finished film (200,000 feet of film was taken during filming). In 1927, *Ben-Hur* played at the Metropolitan on February 11–12. It was also a Metro-Goldwyn-Mayer film directed by Fred Niblo and starred Ramon Navarro as Ben-Hur, Francis X. Bushan as Messala, May McAvoy as Esther and Carmel Myers as Iras. An image of Ben-Hur in his chariot decorated the orange souvenir booklet, which contained six pages of photos from the film. The pamphlet informed the audience that the movie took three years to make and 100,000 people were employed for the famous chariot race. It also declared the movie "a treasure house masterpiece of beauty and art" and said that the story "lifts you out of yourself to heights of rapture and reverence" with "climaxes of magnificent power."

The Metropolitan, referred to by local newspapers as a "Beautiful Temple of Thespis," was razed in 1937. A new three-story building was constructed in its place, housing a Montgomery Ward store.

MAJESTIC

The Majestic Theatre opened on September 21, 1908, at 110 South Broadway. An ad in the *Rochester Daily Bulletin* claimed it to be "The Daintiest Amusement Place in the Northwest." It was small, consisting of only two hundred seats, compared to the Metropolitan's one thousand. Rochester theater patrons eagerly walked under the theater's large white marquee and into the new venue, excited to see opening night's 7:30 p.m. show featuring "The Huntleys." The show would play a one-week engagement. The Huntley Vaudeville Company was a popular entertainment group based in nearby

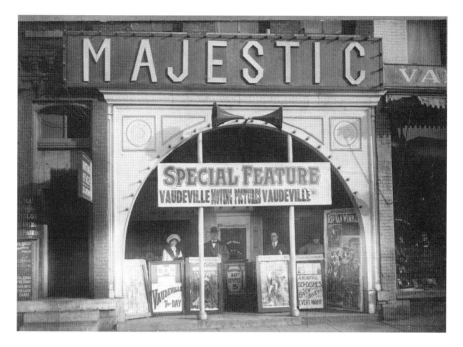

The Huntleys opened the Majestic Theatre in 1908.

Winona. It was owned and operated by husband-and-wife team Ben and Myrtle Huntley. The couple was also an active participant in the traveling variety show. According to a January 16, 2017 *Winona Post* article, the Huntleys called their show the "Majestic Vaudeville Theater Camp" and traveled to and from Midwest cities "in trucks rigged up like motorhomes…erecting circus tents and ushering attendees in to watch music, comedic impersonations, balancing acts, and, later on, films." An undated Winona Historical Society promotional poster advertised "The Huntleys" as having "excellent singing, dancing and comedy, their own orchestra, their own electric plant, their own complete fleet of motor coaches, the finest in the business."

J.E. Reid was responsible for the Majestic, completely remodeling a store building to house his newest theater. The *Olmsted County Democrat*'s September 22, 1908 article about the opening described it as "modern in every respect and safe-guards against fire have been especially provided. A fireproof booth has been prepared in which will sit the moving picture apparatus so that the dangers often coming from the electric machine will be averted. The seats formerly used by the management of the old Grand Opera House have been secured by Mr. Reid. They are leathered upholstered chairs, which insure [*sic*] comfort."

The Majestic Theatre moved to a new location at 212 South Broadway in 1909. The new location held a grand opening on May 18, 1909, and the *Rochester Daily Bulletin* reported the following day:

> *Within its gilded front, the manager had prepared an attractive steel lobby, in the center of which is a ticket office. Above this is placed a booth in which the lantern and films are kept. This small room is entirely fireproof and the contents are protected by a system of water pipes so arranged that a deluge of water can be thrown instantly into the booth. The stage is at the east end of the building but so constructed that the rear exits are not obstructed. The new Majestic occupies the most central location in the city.*

Fire was a big concern for those attending theater productions, and local papers often made it a point to highlight the protocols put in place to prevent such disaster. Early photographic film, created from nitrate, was highly flammable and did cause numerous theater fires throughout the country.

Eventually, the Majestic closed its doors and faded into Rochester's theater history. The July 1, 1976 *Rochester Post-Bulletin* ran a photo of the building, its caption recalling its glory days when "for a dime, a man could walk into the Majestic Theatre and not only watch a movie, but enjoy the slapstick humor of vaudeville comedians. As an added incentive to attend, a set of dishes was given away every night."

EMPRESS

The doors to the Empress, located at 5 South Broadway, opened at 7:30 p.m. on Monday, October 5, 1914. Jack London's *Odyssey of the North*, starring Hobart Bosworth, Rhea Haines and Gordon Sackville, was the night's entertainment. An October 2, 1914 *Rochester Daily Bulletin* article stated, "No expense has been spared in making the Empress as up-to-date and as comfortable as any theatre in the northwest." The newspaper reported that on opening night people crammed the entrance, clamoring to get tickets, and many had to remain outside for the second showing, but by the end of the night, "hundreds of lovers of good photo plays attended the opening and it is needless to say that none was disappointed in this city's picture and vaudeville house." The paper proclaimed the Empress "The Theater Beautiful":

There is probably no theatre in the state, with the exception of Saint Paul, Minneapolis and Duluth, where a prettier effect on the interior has been secured thru the aid of paint and brush. The labor of exceptionally good artists is apparent on the walls and in the paintings which produce so an effective appearance. The men who decorated the Empress theatre have charge of the same work in the Saxe's new theatre recently opened in Minneapolis.

The Saxe Theatre, which would soon change its name to the Strand Theatre, had just opened a month earlier at a cost of $150,000 and with seating capacity of 1,600. The Empress was slightly smaller but was designed in a similar Spanish Renaissance style, although on a far less grand scale. The Empress employed its own orchestra, as did most mid- to large size theaters of the day; even small-town theaters employed at least one piano player to provide a musical score to accompany silent films. A description appeared in the *Rochester Daily Bulletin*'s opening night review:

There are three rows of seats on the first floor and two aisles. The balcony is arranged somewhat like the Metropolitan Theatre. Pink is the prevailing color and other shades are used to blend harmoniously. Plaster of paris figurines form an excellent balancing scheme while the latest indirect lighting system is utilized. The stage presents an appearance of beauty. Nothing has been left undone for the comfort of theatre patrons.

Once again, J.E. Reid had built a beautiful entertainment venue, and the Rochester community warmly embraced another addition to its family of theaters along Broadway, Rochester's very own theater district. The theater was built as a combination vaudeville–movie house, and many vaudeville acts appeared on stage, including a performance by the Chicago Festival Quintette & Dunbar's Salon Singers for four days in July 1915. Vaudeville remained popular, but the motion picture was the new medium, and it fascinated everyone. The Empress didn't disappoint, running two shows—one in the afternoon and another in the evening—every Wednesday and Thursday during its first years in business. Movies included *The White Sister*, starring Viola Allen; *The Battle Cry of Peace*, starring Charles Richman; and *Enoch Arden*, starring Lillian Gish. In the summer of 1916, an interesting back-to-back showing of Charlie Chaplin's *Burlesque on Carmen* and Geraldine Farra's *Carmen* was shown at the Empress. Chaplin's film was a parody of the Cecil B. DeMille–

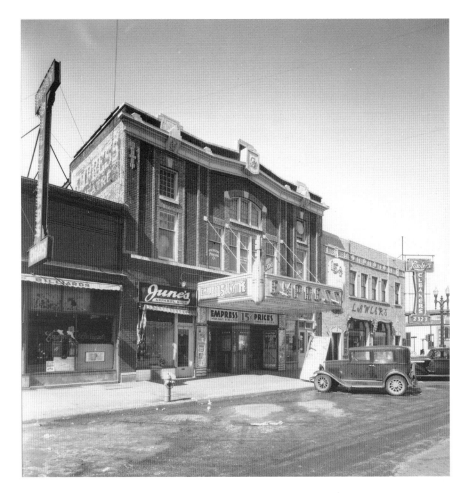

The 1914 Empress Theatre.

directed *Carmen*, based on the 1846 novella by Prosper Merimee about a young woman who helps her gypsy clan smuggle illegal products into Paris by seducing a police officer. During the first week of October 1916, the Billie Burke film *Gloria's Romance* was featured. Billie Burke was called the "Star Supreme" and would later gain eternal fame for her portrayal as Glinda, the Good Witch of the North, in 1939's *The Wizard of Oz*.

During the 1940s and '50s, people flocked to the Empress on Saturday afternoons to watch serials. Each weekend, the audience would enjoy a chapter story within a larger narrative. The "chapters" ended with a cliffhanger, enticing moviegoers to return the following Saturday to see the outcome. This went on for several weeks until reaching a satisfactory

conclusion. The twenty-minute serials ran before the feature full-length film. Going to the movies filled an entire afternoon and was a perfect activity for families. Popular serials included *The Lone Ranger Rides Again*, *The Green Hornet*, *Adventures of Captain Marvel*, *Captain America* and *Ghost of Zorro*.

The "Theatre Beautiful" closed its doors in 1956. It was razed in 1965 to make room for the Michael's Restaurant parking lot.

LAWLER

The Lawler, originally named B.B. Theatre, stole the spotlight from the impressive Empress two years later when it opened on Saturday, September 30, 1916. Martin C. Lawler built the theater at 221 First Avenue Southwest, employing the architecture design skills of George Hoffman & Company and the reputable local contractors George Schwartz & Company to make his vision a reality. The three-story building was 44 feet by 130 feet and cost $50,000. It seated one thousand with a movie screen centered under a classically designed square proscenium arch framed on either side by pilaster Doric-style columns. Above, elegant pendant bowl chandeliers hung suspended between rectangular spaces defined by decorative crown molding. It possessed a façade of compressed brick highlighted by a vertical lighted marquee. The theater also claimed to be fireproof.

A September 30, 1916 *Rochester Daily Bulletin* article claimed it to be "strong in architectural design and beautiful in color treatment....The decorations are harmonious in every way and extremely restful to the eye. Comfortable spring-bottom, spring-edged opera chairs have been provided." The paper's review included a mention of its excellent ventilation system, providing clean air to movie patrons, and that "all of the aisles, the foyer, and the treads on the graceful inclines which will take the place of stairways, have been inlaid with cork so as to remove all noise." The paper declared it a "perfect theatre" and a "wonderfully beautiful building."

Sometime after the 1940s, the original marquee was replaced with a new one, this marquee being far more elaborate and unique, designed in a half-moon shape with additional lighting. By the time of its closure in 1985, the Lawler was a shadow of its former self. It possessed half of its original seating, and according to a July 17, 1985 *Post-Bulletin* article, the theater's manager stated the Lawler was closing because of its deteriorated state, which made it far too expensive to remodel, and that "its build doesn't

The Lawler Theatre opened in 1916.

lend itself to modernization." The last show was the R-rated *Prizzi's Honor*, a comedy-drama starring Jack Nicholson and Kathleen Turner, directed by John Huston. The film was nominated for eight Academy Awards, including Best Picture, Best Director and Best Actor. Anjelica Huston won Best Supporting Actress for her role as Maerose Prizzi.

The Lawler was demolished in 1988. Before its demise, many Rochester residents tried to save it, and the Rochester Historic Preservation Committee listed it as a building worth saving due to its historical significance. However, since no city ordinance existed at the time protecting historic buildings, the Lawler was destroyed. The site is now home to the Minnesota BioBusiness Building.

TIME

When the Time Theater opened on January 8, 1937, its advertising slogan was "Modern as Tomorrow." The theater was located at 15 Fourth Street Southwest, on the Zumbro River's west bank. The opening afternoon

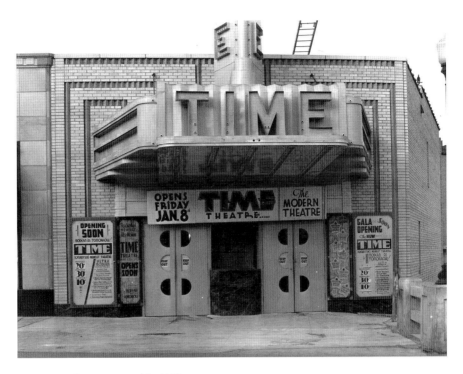

The Time Theater opened in 1937.

film was Universal Pictures' *Three Smart Girls*, a musical comedy starring Deanna Durbin, Barbara Read and Nan Grey as three sisters who play matchmaker to their estranged parents, hoping to get them back together again before their father falls for a gold digger. The opening *Post-Bulletin* article stated that the theater had "air conditioning, a fountain operated by a photo-electric cell, modern decorating throughout and improved acoustical treatment." It seated 420 and would be the last single-screen theater built in downtown Rochester.

The Time was owned by the Rochester Amusement Company from 1937 until 1961, when James R. Fraser of Red Wing, Minnesota, took over its building lease. The final film under the Rochester Amusement Company's Management was *World by Night* on Sunday, December 3. In 1967, Mann Theater of Minneapolis bought the Time. During the 1960s, it became known for showing many X-rated films. However, its last two movies were R-rated: *Some Kind of Hero*, a comedy-drama starring Richard Pryor, and *Quest for Fire*, a prehistoric adventure film. The Time was sold in 1982, and the interior was gutted for restaurant and retail space.

STARLITE DRIVE-IN

It's no secret that Americans have had a love affair with the automobile since its creation. After World War II, a new concept called the drive-in theater combined America's passion for cars with its love of movies. People readily accepted the idea of sitting in vehicles watching a movie while eating, drinking and talking. Thousands of drive-in theaters popped up across the country, and the outdoor theater reached the heights of its popularity during the 1950s and '60s. Rochester's first drive-in theater opened on August 6, 1948, on the southeast side of Rochester at the intersection of U.S. Highway 14 and Marion Road (then called U.S. Highway 52). The Starlite Drive-In welcomed Rochester to "See the Stars Under the Stars."

Designed by the Minneapolis architecture team of Jacob L. Leibenberg and Seeman Kaplan, credited with designing more than two hundred theaters, the Starlite sat on sixteen acres, had five hundred car stalls equipped with an RCA stereo system to deliver cinema sound directly into the car and displayed its screen on a fifteen-foot by thirty-foot tower. A July 23, 1948 *Post-Bulletin* article previewing the new venue claimed, "The screen itself is about five times the size of the screen in the Radio City Theater in Minneapolis and actors are projected on it to a size of 32 feet." Thirty thousand feet of wiring twisted beneath its surface, and it was constructed from one hundred tons of steel. The building housing the concessions, projection booth and restrooms was located in the middle of the outdoor theater and measured forty feet by forty feet. Theater patrons entered from U.S. Highway 14, with cars separating into two lanes approaching two ticket box offices where tickets were purchased, allowing moviegoers to remain in their cars. After the show, cars exited on Marion Road. On opening night, ushers and police were on hand to direct traffic in and out of the theater. Over 150 cars were turned away.

A dedication program was held before the night's movie, led by Rochester mayor Claude McQuillan with special guest Grace McDonald. McDonald was an actress, singer and dancer starring in a variety of low-budget musical B movies produced by Universal Studios during the 1940s. McDonald left Hollywood in 1945, marrying a U.S. Marine and moving to Minneapolis; her last film was 1945's *Honeymoon Ahead*. KROC radio personality Walter Bruzek was the program's master of ceremonies. The opening-night film was *Gunfighters*, a Cinecolor western starring Randolph Scott, Barbara Britton and Bruce Cabot based on Zane Grey's *Twin Sombreros* novel.

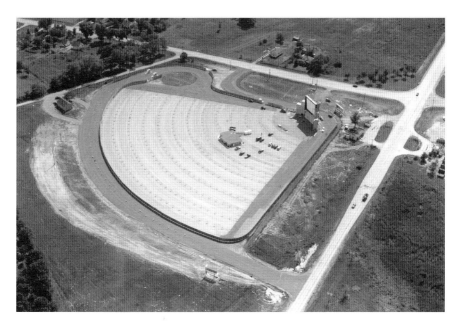

Starlite Drive-In South opened in 1948.

The Starlite advertised itself as a family destination, and people were encouraged to bring children, no matter the age. Parents flocked to the entertainment establishment, enjoying needed escapism. In addition to regular concession stand food and drink, milk and bottle warmers were available. Cigars and cigarettes were also available.

The Starlite averaged three new movies per week. The week's first film was shown on Sunday and Monday, the second on Tuesday and Wednesday and the third on Thursday, Friday and Saturday. It was the only drive-in theater in Rochester until 1971, when Starlite North opened at 4750 North U.S. Highway 63, a larger outdoor theater with eight hundred car stalls and three screens built for $275,000. The original Starlite became known as Starlite South until it closed in 1977. Starlite North continued operation until 1988. A June 16, 1988 *Post-Bulletin* article recorded that *Return to Snowy River, Ernest Goes to Camp* and *The Karate Kid Part II* were shown on screen one; *Back to the Beach, La Bamba* and *Back to the Future* were shown on screen two; and *The Rocky Horror Picture Show, Bad Dreams* and *Creepshow 2* were shown on screen three. With its closure and the shuttering of other area drive-ins during the 1980s, such as the Spring Valley Drive-In, Winona's Sky Vu Drive-In and Austin's Hiway 218 Drive-In, southeast Minnesota residents had to drive to the Twin Cities to experience an outdoor theater.

ENJOYING THE GREAT OUTDOORS

From its earliest days, developing outdoor spaces for recreation, entertainment and nature enjoyment was a priority for Rochester. Even the Rochester State Hospital made outdoor living a priority for patients, purchasing land along Lake Shady in Oronoco for weekly visits and landscaping an expansive garden at its medical campus. Rochester residents flocked to Lake Shady, twelve miles north, and Lake Florence in Stewartville, twelve miles south, during hot summer months for several decades.

Today, Rochester boasts an expansive park system, but development has destroyed or minimized some open green spaces, including Mayo Park. Although still located along the Zumbro River behind the Mayo Civic Center at 30 Civic Center Drive Southeast, it is a greatly minimized version of its former self.

MAYO PARK

In the summer of 1902, a visitor to Rochester, Sara Hubbard, was so inspired by the picturesque beauty of land along the Zumbro River that she penned an opinion piece for the local paper. In the August 9, 1902 *Daily Post & Record* article, she eloquently pleads her case for the city to preserve its beauty by making that area a city park:

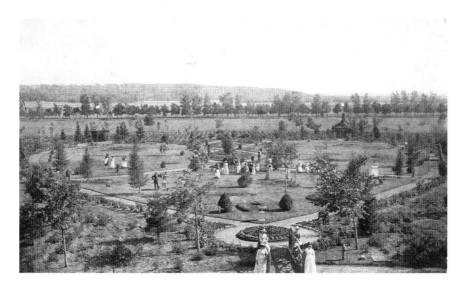

Rochester State Hospital gardens, circa 1900.

There is necessity in every centre of population for open spots easy of access and of attractive features, where solace for the eye and ear and comfort for the spirit shall abound. There should be a pleasure-ground for every human soul under the free sky with its sunshine and stars, on the liberal earth with its bounty of greenery and blossom, its clean fresh breezes and its shining waters. There is health, and life and peace, and joy, and satisfaction in the influence beneficent nature spreads around us.

With a donation from Drs. William and Charlie Mayo and John R. Cook in 1906, the park Sara Hubbard envisioned became a reality. A June 29, 1906 *Post & Record* article declared, "Rochester is to be beautified by a system of parks as no city of its size in the state can boast." This park system comprised Mayo Park and College Hill Park.

College Hill Park would reside on two city blocks on top of a hill, one of the highest vantage points in Rochester, situated between Second Street Southwest and Fourth Street Southwest, then called Zumbro and College Streets. The *Post & Record* described the view from College Hill as "one of the best for miles around: below lies the shaded city, the sparkling river; beyond them the other slopes to the four points of the compass, and the fields of growing grains." Steep, wide steps would mark the entrance to College Hill Park. Mayo Park was the larger park, situated in the heart of the city.

Rochester hired Frank Nutter, a Minneapolis landscape architect and engineer, to design the Mayo Park layout. Nutter designed several Minneapolis green spaces, including Chute Square on Nicollet Island, and was the landscape designer of Interstate State Park, on the St. Croix River. It was the first park of its kind, shared by two states, Minnesota and Wisconsin. The city approved the design for Mayo Park, and work commenced. Two bathhouses were built, one for young children and one for older children and adults. The August 2, 1907 *Post & Record* edition described, "Two central rooms will contain bathing suits, and on either side will be individual dressing rooms, there being 58 of these, 33 on the men's side and 25 on the other. At the front, steps will lead down into the water. The entire building is to be elevated from the ground about 5 feet." But just as the park began to take shape, a storm swept through on June 23, 1908, causing the Zumbro River to flood. The new bathhouses, walkways and bridges were destroyed. The city wasn't swayed and began reconstruction immediately.

Rochester residents were quite proud of their sixteen-acre Mayo Park, and that pride grew with the construction of a large band shell in 1915. The idea for the band shell came from local business owner and musician Ralph L. Blakely. He approached Dr. William Mayo with his idea, insisting summer music would benefit patients. His passionate appeal won Dr. Mayo over, and he and his brother Dr. Charlie donated money for the project. Design plans from the St. Paul firm of Ellerbe & Co. were accepted; the cost totaled $18,500. A band played summer concerts three nights a week for several years. In the beginning, Blakely directed a band composed of professional musicians from larger cities. These musicians made Rochester their temporary home during the ten-week summer concert season. During concerts, young couples rented boats and cruised the river under bridges and around the park's island, which was filled in around 1919. The Mayo Park Band Shell's last concert was held in August 1950, and the thirty-six-year-old structure was torn down in 1951. Not long after the band shell was built, the Victory Arches were put in place. The arches were a result of a community campaign to raise funds for a memorial for Olmsted County soldiers who died in World War I.

Other notable park objects included Abraham Lincoln and George Washington statues placed a few feet from each other along a garden path in a section of the park known as Statuary Park. The Mayo family purchased the marble statues in Italy and donated them to the park. Both statues were vandalized in 1938. By 1954, they had been removed and placed in storage, eventually vanishing into Rochester legend. Many longtime residents claim

The 1915 Mayo Park Band Shell.

Mayo Park entrance near East Center Bridge, circa 1915.

Mayo Park's Victory Arches.

they are buried under Soldier's Field near where the current YMCA is located, but no one knows for sure.

Another lost Mayo Park artifact is the Daughters of the American Revolution Sundial. Dedicated on May 28, 1914, in honor of the Rochester DAR chapter's founder and first regent, the sundial stood near the park's greenhouse. The inscription at the bottom of the sundial, engraved on a bronze tablet, read: "Erected by Rochester Chapter D.A.R. In Memory of Abbie F. Faitoute First Regent." Engraved on the top were the words "Amidst ye flowers, I tell ye hours." Like the presidential statues, the sundial went into storage when Statuary Park was removed to make room for a parking lot, the eventual location of the current public library and the expansion of Mayo Civic Center. Statuary Park also was home to a Civil War cannon until 1942, when the U.S. government dismantled it for World War II use.

One of the more unique attractions was Mayo Park Zoo. The zoo's animals included elk, foxes, raccoons, owls, deer, wolves, deer, buffalo and bears. A Yellowstone National Park buffalo cow and bull arrived from Cody, Wyoming, on October 31, 1926. A small herd was created from these first buffalo, and a rare white calf, which didn't live long, was also born. By 1939, the annual cost of feeding them became too much for the city, and they were shot and killed. Bear triplets were born at the zoo in January 1938 but were moved to an Illinois zoo that summer. After the zoo's closure in 1942, the remaining bears met the same fate as the buffalo.

Above, left: Abraham Lincoln statue.

Above, right: George Washington statue.

Left: Daughters of the American Revolution 1914 sundial.

Despite the loss of most Mayo Park relics, a few remain. The historic William Dee Cabin, built in 1862, moved to the History Center of Olmsted County, where it is preserved and open to the public. The Thunderbird Totem, a Native American totem pole, awaits a new location, currently stored in a park system warehouse. The Thunderbird Totem was placed in Mayo Park in 1932. The Vancouver Hootka carved the totem from a white pine. It is twenty-two inches in diameter and thirty feet long. Carved into the wood from top to bottom are a thunderbird, medicine man, whale killer, owl and bear.

Music still permeates through Mayo Park on Sunday nights in August and September, when Rochester's Down by the Riverside Concert Series hosts free live concerts, reminiscent of those long-ago 1915 band shell summer concerts.

LAKE SHADY, ORONOCO

Losing the county seat to Rochester was quite a blow to Oronoco; however, it wasn't long before it became a recreational destination when a mill owner built a dam on the Zumbro River, creating Lake Shady. Elsie Boutelle writes in *Oronoco: Past & Present* that Oronoco's residents "envisioned Lake Shady as one of the finest pleasure resorts in the Northwest, with a famous drive around the lake, a magnificent summer hotel and last, but not least, a street car line running from Pine Island [located one mile north]….Cheap and ready transportation afforded by the motor car began to materialize this dream. The lake and the town enjoyed a heyday as a summer resort."

Many prestigious Rochester residents, including Dr. William and Dr. Charles Mayo, Dr. Henry Plummer and hotel owner John H. Kahler, built summer cottages along the lake's edge. Dr. Charles William Mayo, the son of Dr. Charles Horace Mayo, reflected on his boyhood summers in Oronoco in his 1968 autobiography *Mayo: The Story of My Family and My Career*:

> *Father and Uncle Will built a cottage on the Zumbro River, near Oronoco, and we summered there, the two families alternating. Sometimes Father and Uncle Will were kept so busy in surgery that they could come only on the weekends, but we children had the run of the barn and the boats. I remember sitting on the dock fishing with a cane pole, and I can still smell the water, a good smell, and hear the little waves lapping on the sides of the boats.*

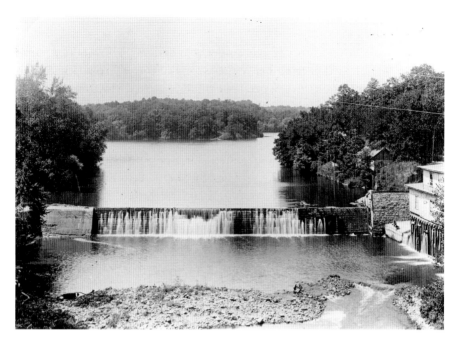

A dam on the Zumbro River formed Lake Shady.

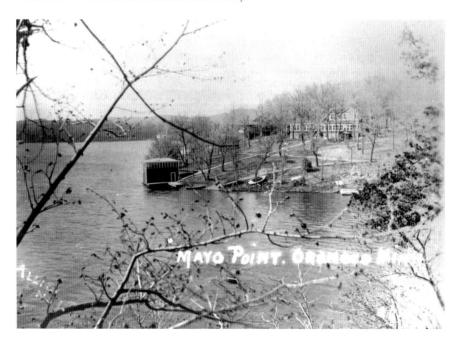

The Mayo Cottage.

Mayo also shared a story about a new boat arriving. His mother, Edith, was none too pleased because her requests for a baby grand piano had been denied. The funny story gives a personal glimpse into the Mayo family. Mayo recalls, "One day we were at the cottage, a motor launch was unloaded into the lake. It was a beautiful boat and mother wondered aloud who owned it. Father said proudly, 'We do. What shall we name it?' Mother's eyes glittered. 'How about Baby Grand?' she suggested icily. She got her piano as soon as we returned to the red house [the Mayos' city home before Mayowood]."

In its glory years, Oronoco was a booming little city May through September. A December 16, 1992 *Pine Island Record* article described the resort town:

> *A large dance pavilion was built near the park and was a popular recreation center. A bowling alley, a riding stable, some rental cottages, 30 to 40 rental row boats, a Boy Scout camp, a fine resort hotel, a scenic lake drive, big tent outdoor theatre, roller skating and in winter fishing and ice skating all made the years around the turn of the century truly golden years of the lake as a recreation center.*

It wasn't easy keeping the lake. Mother Nature became its greatest enemy. An 1859 flood destroyed the first dam and gristmill. Another dam and mill were built, but a fire destroyed the mill in 1879. A smaller dam replaced it, but a 1923 flash flood wiped out the dam and mill, draining Lake Shady in two hours. It would be over a decade before Lake Shady would be reborn, thanks to a Works Progress Administration project in 1936 that funded the building of a $70,000 concrete dam. The new dam created a bigger lake, expanding it from 130 acres to 179. This dam survived until it was damaged beyond repair due to massive flooding caused by a September 23, 2010 rainstorm. Lake Shady was gone. A new dam would not be approved. The loss of its heart was tough for Oronoco residents, but community members joined forces to brainstorm ways to reinvent the Lake Shady lakebed. This resulted in the creation of two projects, funded by grants and tax dollars, to remove the dam and create a recreational area that includes a stream for fisheries and outdoor water sports such as canoeing, native grasslands for wildlife and biking and walking trails that will eventually hook up with the nearby Douglass Trail, connecting Oronoco to Rochester and Pine Island.

LAKE FLORENCE, STEWARTVILLE

Just like Lake Shady, Stewartville's Lake Florence owed its existence to the building of a mill and dam. Charles Stewart, the city's namesake, constructed the dam on the Root River in 1857, creating a body of water known for several years as Mill Pond until it was changed in honor of Stewart's daughter-in-law, Florence. Florence would eventually move to Rochester, but she kept a summer cottage on the lake for several years and had a personal connection to the lake, besides being married to the son of the man who created it. *The Stewartville Story* explains how "one evening, when the Stewarts were enjoying a boat ride, Mrs. Stewart (Florence) was letting her hand glide through the water and her diamond ring slipped off her finger into the lake. It was never found, and for many years, divers were always hoping to find it."

J.M. Cussons bought the Stewartville Flour Mill on Lake Florence in 1898. He installed new machinery and remodeled the mill, renaming it Cussons Mill. Cussons Mill stood on the east end of Lake Florence until closing in 1938 and falling to the wrecking ball a few years later. The dam washed out in 1902 but was rebuilt. In 1950, a thirty-foot limestone section of the dam crumbled and had to be rebuilt. Four decades later, the Root River waters flooded again, washing out part of the dam. The city decided it didn't have the funds to finance dredging the lake and building a new dam.

The *History of Olmsted County 1910* called it "the most extensive body of water in southeastern Minnesota, and this together with its natural parks and scenic beauty, makes it one of the most desirable resorts during the heated term of the summer months." The editors of *The Stewartville Story* wrote that in 1906 and 1907, "large picnic parties would come from Osage, Iowa, and other stations south on the excursion train. They would walk from the depot to the park with their well laden picnic baskets, go up river in the 'Idle Hour' for the day and return via the railroad in the evening." The Cussons owned the twenty-four-foot launch called the *Idle Hour* that carried twenty-five passengers for lake excursions. The *Idle Hour* was described in *The Stewartville Story* as having "a canopy top[,] and side curtains could be pulled down if a party were caught out on the lake in a shower. This was used on Sundays, evenings and holidays until 1917 when it was sold."

Lake Florence was a popular spot all year round. According to *The Stewartville Story*, between 1910 and 1930:

> *In the autumn season, grade school children had annual wiener and marshmallow roasts at the same stone quarry across the lake.... The hike*

Boaters prepare for a July 1894 outing on Lake Florence.

across the dam and around the lake after school, the big bonfire, the browned marshmallows, and roasted wieners with buns, the singing and storytelling around the fire, the hike back (someone always fell in), the folk dances and singing games in the park were all part of these happy occasions. In winter, cutter riding on the ice was also a popular pastime on Sunday afternoons and moonlight nights. The clanking of the horse hoofs on the ice, the merry jingle bells and the happy singing voices were sounds never to be forgotten.

Groups of ice skaters glided across the lake and warmed themselves by large bonfires before the 1960s and '70s, when the lake boasted a warming house and two ice rinks, one designated for hockey play. During the late 1800s and early 1900s, large chunks of ice were harvested in January and stored for summer refrigeration. In May, children and adults explored the surrounding woods for wildflowers, collecting bouquets of violets, bluebells, trillium and columbine to use in May baskets. Fishermen enjoyed catching trout, pike, crappies, sunfish and perch.

Although the lake disappeared, Florence Park is still a popular outdoor space for the Stewartville community. Located on Lakeshore Drive Northwest, it has hiking and biking paths, a fishing pond, a playground, a park shelter and Florence Pavilion, which can be rented for events.

Chapter 9

HORSE THIEF CAVE

A notorious bank robbery of the National Bank in Northfield, Minnesota, on September 7, 1876, planted the roots for several legendary stories handed down generation to generation in many southern Minnesota towns. Why? Well, the culprits were the members of the infamous James-Younger Gang. After the robbery, a posse quickly organized and was soon in pursuit. Most members of the gang were wounded from the shootout. They split up once reaching Mankato and proceeded to elude authorities for a fortnight. The Younger brothers eventually surrendered near La Salle, while the James brothers acquired fresh horses and escaped into the Dakota Territory. Despite the documented fact that the group headed southwest, people in the southeast part of the state couldn't resist telling tall tales revolving around the group hiding out near farms and towns. Rochester, too, has its myth about how the James-Younger Gang stole horses and hid in a cave outside the city limits along Rochester's eastern edge, avoiding arrest. This cave even has a name: Horse Thief Cave. Regrettably, there exists no historical fact connecting the James-Younger Gang to this area. However, it does make a great story.

The legend of Horse Thief Cave lives on, and although the James-Younger Gang most likely never hid within its cool depths, it's possible other horse thieves did. Horses were a necessity, not a luxury, and everyone benefited from having a horse. So it wasn't unusual for equines to be taken from rural farms during the night, never to be seen again. Two Rochester-area townships, Haverhill and Viola, created anti–horse thief societies. The

Haverhill Anti–Horse Thief Society was organized in 1880, while the Viola Anti–Horse Thief Society was created in 1874.

So, does Horse Thief Cave exist? And if so, where? Well, it's difficult to pinpoint where the actual Horse Thief Cave is located. And perhaps it doesn't refer to just one cave but encompasses many under one name. Olmsted County, as well as its bordering counties, sits in what is called the Driftless Area. The Driftless Area includes parts of four states: Illinois, Minnesota, Iowa and Wisconsin. The area was bypassed by the last glacier melt, which happened 100,000 years ago. It has a topography consisting of impressive bluffs and deep valleys, and a multitude of underground springs, streams, waterfalls and caves.

Within an hour south of Rochester are two cave attractions: Mystery Cave and Niagara Cave. Both are located in Fillmore County. Mystery Cave is located in Preston, while Niagara Cave is located in Harmony. Niagara Cave was discovered in 1924 when a farmer's missing pigs fell through a hole and into the cave. It wasn't the first time an area cave was discovered because of animals. "A curious geological incident occurred on a farm of Mr. Mountain in the summer of 1870," recalled the editors of the *History of Olmsted County 1910*. "A bunch of five horses were huddled together in a pasture during a heavy July rain, and the next morning were found all at the bottom of a pit eighteen feet deep and twelve feet wide at the top, which had sunk under them. They were unhurt, though tumbled in a heap and were lifted out." This incident happened in Rochester. Another cave was explored a few months later in Haverhill Township. According to the *History of Olmsted County*:

> *The existence of a cave, the resort of wild cats and wolves on the farm of I.C. Van Hook, about three miles north of Rochester and near Lake City Road, had been known in the neighborhood but not explored till a Sunday in December 1870, when five boys, from twelve to sixteen years old… entered it. They found at the bottom of a slope of fifteen feet a pit hole and beyond it a large irregular shaped chamber 260 feet long, forty feet wide and about thirty feet high, with rocky walls hung with stalactites, some of them a couple of feet long.*

The Rochester State Hospital took advantage of the cavernous spaces beneath its buildings, as the continuous cool temperature provided a perfect place for food and drink storage. And one local farmer, after discovering a small cave entrance on his property, worked diligently with hand tools

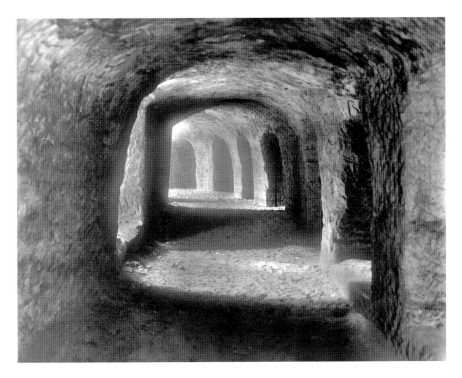

Rochester State Hospital caves were used as storage.

to expand it. The *Rochester Post* described in great detail Walter Hurlbut's impressive stock tunnels within a hill on the east side of Rochester in a February 27, 1885 article:

> *At the south side of the farm is a high bluff, and about half way up, Mr. Hurlbut has dug a winding tunnel about four hundred feet in length. From this tunnel branch off on either side small cells six by ten feet in size, and six feet high, and on the west side openings have been made and windows put in, which gives plenty of light. There is also a well in about the center of the tunnel, which furnishes an endless quantity of water. There is another tunnel ninety feet in length which branches off from the main tunnel. These tunnels and cells are filled with hogs and chickens, there being 118 hogs and 150 chickens there now.*

Forty years later, in 1925, Helen Wickham Moore shared her experience exploring a Rochester cave in an unpublished report called "Horse Thief Cave." Moore's descriptive detail coincides closely with descriptions of

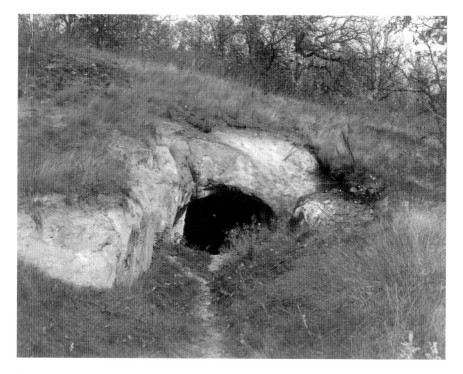

Horse Thief Cave's location is not known, but the city's east side has many caves.

Hurlbut's cave. Was she in Hurlbut's stock cave? It's very likely. "Upon entering the cave, we found ourselves in a corridor five hundred feet in length, which extends zigzag fashion in long lines through the north side of the hill," recorded Moore. "On the west side of the corridor are stalls, thirty-three in number, each large enough to accommodate two horses." Moore wrote that "evidence of a well was found east of the main corridor" and that the air was "light and dry owing to a series of holes drilled at intervals through the roof of the cave at the top of the hill....Light was admitted through holes about eighteen inches in diameter picked through the east side of the main corridor to the outside of the hill." Moore acknowledged that those living in the area called it Horse Thief Cave, saying it was once used as "a rendezvous of a band of horse thieves who...used it as a place to conceal stolen horses." But despite lack of evidence supporting this claim, the cave's unknown past enchanted Moore:

> *Though the true history of this romantic place may never be disclosed, it is thrilling to imagine the scenes once undoubtedly enacted there. The*

arduous and what must have seemed well nigh endless task of excavation; the stealthy night arrivals of weary horsemen and mounts; the silence and secrecy of the place and the occasional fear of detection. One who has never wished that the walls about him had the power of revealing past scenes would surely experience that longing when visiting mysterious, crumbling Horse Thief Cave.

Perhaps a female horse thief, jailed after stealing from Rochester livery stable owner R.A. Perry, ducked into a cave for a time to avoid the sheriff on her way toward La Crosse, Wisconsin, in the fall of 1889. A female horse thief was unusual and made interesting news. Even St. Paul's *Daily Globe* ran an article about Rochester's incarcerated horse thief in its September 19, 1889 issue:

She is feeling very despondent, and will give no reason for running off with the pony. The reason, however, is very obvious. She had not a cent of money, and, with a two weeks' board bill to pay, she took this means as the last resort of getting away from the town. She gives the name of Mrs. Mary Hyatt, is twenty-two years old, quite good looking, and claims to be married to one Sam Hyatt, a musician connected with W.C. Coup's Show. She came here last week while the show was performing at the fair, and she and a fellow whom she claimed was her husband were around together, but when the show left he left her behind.

The topic of Horse Thief Cave has been discussed several times over the years, and although many people have shared their thoughts on where the cave might be located, no one knows for sure. Regardless, its entrance can no longer be found, most likely filled in long ago to detract and protect curious explorers. The myth lives on, the legend continues.

BIBLIOGRAPHY

Allsen, Ken. *Old College Street: The Historic Heart of Rochester, Minnesota.* Charleston, SC: The History Press, 2012.

Anderson, George. "Lake Shady Continued." *Pine Island Record*, December 16, 1992.

Aune, Ray. *Highlights of the Olmsted County Fair, 1860–1990.* Rochester, MN, 1990.

Bee, Roger, Gary F. Brown and John C. Luecke. *The Chicago Great Western in Minnesota.* Anoka, MN: Blue River Publications, 1984.

Bicentennial Book Committee. *The Stewartville Story, 1857–1976*: Bicentennial Edition. Stewartville, MN: Bicentennial Book Committee, 1957.

Boutelle, Elsie. *Oronoco: Past & Present.* Zumbrota, MN: Sommers Printing, Inc., 1983.

Calvano, Alan. *Postcard History Series: Rochester.* Charleston, SC: Arcadia Publishing, 2008.

Capelle, Aleta. "Lawler Theater to Close." *Post-Bulletin*, July 17, 1985.

Cohn, Victor. "Mayos Began There 60 Years Ago: 'Old' Hospital Being Torn Down." *Minneapolis Sunday Tribune*, November 15, 1953.

Dougherty, Mike. "Rochester Brewery Roared Until the '20s." *Rochester Post-Bulletin*, March 9, 2005.

El-Hai, Jack. *Lost Minnesota: Stories of Vanished Places.* Minneapolis: University of Minnesota Press, 2000.

Freeberg, Ron. "Ex-Manager: Zumbro 'Was My Life.'" *Rochester Post-Bulletin*, August 6, 1987.

————. "Zumbro Bows to Progress: Guests, Workers Call Closing Sad Event." *Rochester Post-Bulletin*, August 6, 1987.

Grossfield, Edie. "No Longer Living in Obscurity." *Rochester Post-Bulletin*, September 23–24, 2006.

Hansel, Jeff. "Historic Guest House to Close." *Rochester Post-Bulletin*, November 2006.

History of Olmsted County, Minnesota. H.H. Hill & Company: Chicago, 1883.

Hoverson, Doug. *Land of Amber Waters: The History of Brewing in Minnesota*. Minneapolis: University of Minnesota Press, 2007.

————. "Pride of Rochester: The Schuster Family's Union Brewery." *American Breweriana Journal* 134 (March/April 2005).

Kahlert, Gerald. "Membership Was $10 a Year—Library Once Like an Exclusive Club." *Rochester Post-Bulletin*, April 1966.

Karnowski, Steve. "Sleuths Trace 1st Slave Freed by Lincoln to Rochester." Associated Press. *Rochester Post-Bulletin*, July 20, 2015.

Larsen, Arthur J. "Roads and Trails in the Minnesota Triangle, 1849–60." *Minnesota History* 11 (December 1930).

Leonard, Joseph A. *History of Olmsted County, Minnesota*. Chicago: Goodspeed Historical Association, 1910.

Mayo alumnus. "New Dimensions Arise from First Mayo Building." *Mayo Foundation* 4, vol. 22 (Fall 1986).

Mayo, Dr. Charles W. *Mayo: The Story of My Family and My Career*. Garden City, NY: Doubleday & Company, Inc., 1968.

McClure, Ethel. *More Than a Roof: The Development of Minnesota Poor Farms and Homes for the Aged*. St. Paul: Minnesota Historical Society, 1868.

McCracken, Ken. "'First' Mayo Clinic Surrenders to Time." *Rochester Post-Bulletin*, August 11, 1986.

Merriott, Cliff. "Cook House, Rochester Show Place of Years Gone By, to Be Torn Down." *Rochester Post-Bulletin*, March 26, 1949.

Morris, Lona. "Rochester Iron Works Building, Familiar Landmark, Being Razed." *Rochester Post-Bulletin*, September 21, 1957.

Olmsted County Democrat. "Bought the Chute." February 10, 1911.

————. "Central Fire Station: The Imposing Building at the Head of Broadway Is Now Complete and Ready for Dedication." December 15, 1898.

————. "The Chute Complete." November 8, 1907.

————. "City and County Local News." May 25, 1906.

————. "City and County Local News." June 7, 1907.

————. "Dedicated and Opened." January 18, 1901.

———. "The Inquest Ends." November 15, 1902.

———. "John A. Milling Company." July 28, 1905.

———. "Moved Yesterday." December 7, 1900.

———. "New 'Majestic' Theatre." September 1908.

———. "Northwestern Hotel Now Open on Broadway." November 20, 1908.

———. "Plans Are Here: Approved First Floor Plans for Cook House Block." August 9, 1901.

———. "Preliminary Plans." May 11, 1900.

———. "Raze the Woolen Mill: Rochester Building Being Torn Down and Removed." December 31, 1909.

———. "Schuster Brewery." May 4, 1900.

———. "Tondro Mill." May 12, 1898.

———. "A Visit to the Woolen Mills." December 2, 1897.

———. "Zumbro Opens with Eclat." March 22, 1912.

Page, Barb. *150 Years of Memories, 1860–2010: Olmsted County Fair*. Rochester, MN, 2010.

Peterson, Minard, and Betty and Elmer La Brash. *History of the Rochester Fire Department, 1866–2000*. Minneapolis: University of Minnesota Printing Services, 2000.

Pieters, Jeff. "US 52: The Future Is Now: From Dirt Road to Six-Lane Highway." *Rochester Post-Bulletin*, October 1, 2005.

Raygor, Mearl W. *The Rochester Story*. Rochester, MN: Schmidt Printing Inc., 1976.

Reicks, Rod. "The LATE Show: Starlite North Fades to Black Saturday." *Rochester Post-Bulletin*, June 16, 1988.

Reising, Jerry. "State Hospital Closing Was Partisan." *Rochester Post-Bulletin*, May 31, 2006.

Rochester City Post. "Fairgrounds for State Fair." June 15 1867.

———. "Minnesota State Fair Opening Day." October 1, 1867.

Rochester Daily Bulletin. "First Train." October 13, 1904.

———. "Formally Opens." September 30, 1916.

———. "Hundreds Inspect New Worrall Hospital at New Year Opening." January 2, 1919.

———. "The Mayo Clinic Building Is Formally Opened." March 7, 1914.

———. "The New Court House." August 17, 1867.

———. "New Empress Is Resplendent on Opening Night." October 6, 1914.

Rochester Post. "Building New Mill." September 19, 1890.

———. "Death of Mrs. Pierce." May 3, 1895.

———. "Diptheria." January 4, 1884.

———. "Fire at Broadway House." November 18, 1881.

———. "Henry Schuster Funeral." August 21, 1885.

———. "The Killing of Combs." June 28, 1889.

———. "The Need for Railroad Competition." March 23, 1872.

———. "A New and More Convenient Reading Room." August 26, 1876.

———. "The New Hotel." May 1, 1869.

———. "Olmsted County Courthouse." December 16, 1892.

———. "Report of the Grand Jury." June 21, 1889.

———. "Rochester Public School Building." May 22, 1869.

———. "Rochester's Disaster." August 24, 1883.

———. "St. Francis Academy: The New Catholic School." July 27, 1877.

———. "The Success of the Free Reading Room." August 19, 1876.

Rochester Post & Record. "Beauty of Fire Drill Demonstrated in Blaze Doing $1,500 Damage to the Northrop School Building." February 10, 1910.

———. "Formal Opening of Clinic Buildings Attract Hundreds of People Friday." March 7, 1914.

———. "Large Addition to Chute Sanitarium." March 22, 1907.

———. "Making Fine Goods." May 26, 1899.

———. "Reid's Theatre Dedicated." February 11, 1902.

———. "Rochester Milling Company." August 12, 1910.

———. "A Sanitarium Is Planned." August 17, 1906.

Rochester Post-Bulletin. "Annual Sales of Rochester Dairy Company, City's Largest Plant, Approach Million Mark." April 27, 1938.

———. "Century of Caring Observed." September 27, 1989.

———. "City Landmark to Give Way to New Clinic Building." January 5, 1950.

———. December 12, 1978.

———. "Disappeared Landmark Had Long History Here." September 23, 1953.

———. "ERA OVER: Demolition of Colonial Hospital Now Complete." September 18, 1985.

———. "Fire Routs Guests from Cook Hotel." February 3, 1947.

———. "Firm Handles 330 Tons of Milk Daily." October 12, 1944.

———. "Garner's Bill Provides P.O. for Rochester." May 27, 1932.

———. "H&H Dairy Company Sold to Rochester Dairy Firm; Hall in Business 72 Years." August 24, 1937.

———. "High School Library Mural by St. Paul Artist to Depict Old Trail to Dubuque." November 22, 1937.

————. "Historic Preservation Panel: Savage Must Explain Demolition." March 20, 1987.

————. "Justice Leaves Her Perch." Sept 24, 1958.

————. "Mill City Artist and Wife Install Murals on the Wall of the Post Office Here: Mr. and Mrs David Granaham Complete Work after Long Sunday Session." October 3, 1937.

————. "New Addition to Colonial to Open June 1: Building Program Includes Remodeling of Old Hospital Wings." May 11, 1950.

————. "New Drive-In Theater Here to Be Dedicated Tonight." August 6, 1948.

————. "New Outdoor Movie Filled for Opening." August 7, 1948.

————. "Old Fire Hall, Sentinel over Broadway 33 Years, Vacated; Firemen Occupy New Quarters." October 23, 1930.

————. "Old Mill Land Donated for Park." October 27, 1986.

————. "Old Mill, Long-Standing Landmark, to Be Razed." August 3, 1951.

————. "Parking Lot to Replace Damon Hotel, One of the City's Best-known Landmarks." November 10, 1960.

————. "Pioneer Stagecoach Travel in Area Was Difficult and Complicated, Society Told." June 14, 1930.

————. "RDC Set to Formally Merge with 11 Other Milk, Marketing Co-ops." October 31, 1969.

————. "Riding the 'Red Bird' in Rochester." November 9, 1988.

————. "Rochester Dairy Uses Milk of 3,000 Herds." November 20, 1957.

————. "Rochester's New $178,000 Post Office Opens." July 24, 1934.

————. "State Hospital Farm Era to End with Heifer Sale." June 12, 1967.

————. "State Hospital's Old Rock Crushing Plant Demolished with Dynamite." October 7, 1955.

————. "Time Catches Up to the Colonial Hospital." June 6, 1985.

————. "Worrall Annex Razing Attracts Onlookers." September 12, 1967.

————. "Zumbro Hotel Comes Tumbling Down: 75-Year-Old Hotel Makes Way for Rochester Plaza Hotel Complex." October 14, 1987.

Rochester Record & Union. "Construction on New Mill." May 16, 1879.

————. "The Great Blizzard." January 20, 1898.

————. "The Inebriate Asylum." October 30, 1876.

————. "John A. Cole Buys Mill." September 13, 1890.

————. "Library Dedicated." March 11, 1898

————. "The New Library." November 26, 1897.

————. "The Pierce House." August 3, 1877.

Rochester Republican. "The State Fair." October 11, 1866.

Saint Marys Hospital. *Pictorial Tour of Saint Marys*. Rochester, MN: Saint Marys Hospital, 1940.

Schlitgus, Ernest H. "The Dubuque Trail." *Olmsted County Historical Society Monthly Bulletin* 2, no. 2 (February 1960).

Severson, Harold. "Iron Works, Pioneer Here, Still Progresses." *Rochester Post-Bulletin*, November 8, 1957.

———. "Now on Display at Historical Center—Curator Scurried to Save Mural in Old Post Office."

St. Mane, Ted. *Images of America: Rochester, Minnesota*. Charleston, SC: Arcadia Publishing, 2003.

Wickham, Helen Moore. "Horse Thief Cave." Unpublished report. Minnesota Historical Society, 1925.

Websites

Cartwright, R.L. "Winged Menace: The Minnesota Grasshopper Plagues of 1873–1877." June 11, 2013. www.minnpost.com/mnopedia/2013/06/winged-menaceminnesota-grasshopper-plagues-1873-1877.

City of Rochester. "Water Primer: An Introduction to Our Water Resources." www.rochestermn.gov/home/showdocument?id=1202.

FOIH: Friends of Indian Heights. www.foih.org/history.html.

Helmich, Mary A. "Stage Style—Not All Were Coaches!" California State Parks. www.parks.ca.gov/?page_id=25449.

Kirkbride Buildings. www.kirkbridebuildings.com.

Methodist-Kahler School of Nursing Alumni Association. www.mayo.edu/methodist-kahler-school-of-nursing-alumni-association/about/history.

Minnesota State Fair Foundation. www.msffoundation.org/state-fair-history.

National Weather Service. "Rochester Tornado, August 21, 1883." www.weather.gov/arx/aug211883.

University of Minnesota. "Biography: Cyrus Northrop, 1884–1911." president.umn.edu/about/presidential-history/cyrus-northrop.

Other Resources

History Center of Olmsted County Archives

INDEX

ABOUT THE AUTHOR

Amy Jo Hahn is a native of southeast Minnesota. She grew up in Harmony, a small rural town about an hour south of Rochester. She currently resides in Rochester. She has a bachelor's degree in mass communication from Winona State University, a master's degree in mass communication from Arizona State University's Walter Cronkite School of Journalism and Mass Communication and a historic preservation certificate from Bucks County Community College, where she was awarded the college's Historic Preservation Award. She has worked as a magazine editor, television news producer, online content writer and communications consultant for the Mayo Clinic Office of Patient Education, where she won several National Health Information Awards during her tenure. She has published several historical articles and is also a published romance author.

Visit Amy at www.facebook.com/amyhahnauthor or www.amy-hahn.com. Contact Amy at amy@amy-hahn.com.

Visit us at
www.historypress.net
·······································